MURDER MOST
TEXAN

MURDER MOST TEXAN

BARTEE HAILE

THE
History
PRESS

Published by The History Press
Charleston, SC 29403
www.historypress.net

First published 2014

Manufactured in the United States

ISBN 978.1.62619.717.6

For Brett, the son who fills my life with joy and pride.

Contents

Introduction

We Texans love our history, our folklore and our myths. But we sometimes run into trouble when we cannot tell the difference.

For example, many of us believe that crime and punishment was a cut-and-dried affair in the "good old days," that the Texas Rangers and peace officers on down the line always got their man and the wrongdoer always got what was coming to him. And, oh yes, jurors were not as easily fooled by smooth-talking lawyers as they are nowadays.

I may have thought that, too, thirty-one years ago before I began writing "This Week in Texas History" for small-town and suburban newspapers. But the research that went into the 1,600 columns I have written to date has taught me a thing or two, and one of those things is that criminals who were as guilty as sin beat the legal system in the nineteenth and twentieth centuries with appalling regularity. Crime may not pay, but sometimes it does not cost all that much! And on the flip side of that same coin, the innocent were all too often convicted of crimes they did not commit.

All this needed saying before you dive into the collection of sixteen classic murder stories from the Lone Star past that compose *Murder Most Texan*. While I have tried to keep the graphic details to a minimum for your stomach's sake and mine, murder can be messy. Rest assured, I did not choose these specific cases for their shock value but rather for their inherent worth as fascinating glimpses into the dark side of human nature.

That and the simple fact that each one of these real-life stories is a part of Texas history and a darn good read!

CHAPTER 1
Texas Town Never Forgot "Diamond Bessie"

Present-day Jefferson is a popular place with the bed-and-breakfast set and travelers, who cannot get enough of quaint antique shops. Those visitors who take the time to dip their toes in the history of this out-of-the-way tourist attraction are invariably surprised to learn it was once Texas' second-busiest port and sixth-largest city.

How could a town hundreds of miles from the Gulf of Mexico and less than twenty from the Louisiana border ever have been a bustling inland harbor? The answer is a freak of nature known as the "Red River Raft," a centuries-old logjam that made a network of interconnected waterways navigable all the way to Shreveport and New Orleans. Texas was still an independent republic in 1843, when the first steamboat reached Jefferson, ushering in a period of prosperity and growth that peaked three decades later with a population of 7,300.

The glory days came to a dead stop in 1873 with the removal of "the Raft" and the completion of the Texas & Pacific (T&P) Railroad line from Texarkana to Marshall. Overnight, the level of the Red River dropped precipitously, and Shreveport replaced Jefferson as the port of choice. The T&P linked the bypassed community to the main line the next year, but token rail service was not enough to prevent businesses from closing and residents from leaving town.

Jefferson was still managing to keep up appearances when a well-dressed couple stepped off the train on January 19, 1877. They took a carriage to the Brooks House, where the man signed the hotel register

as "A. Monroe and wife." Curious locals heard him call his eye-candy companion "Bessie," a name they amended to "Diamond Bessie" because of the expensive jewels she wore around her neck and in rings on most of her dainty fingers.

Jeffersonians would learn in time the true identities of the twosome they found so fascinating. Both were the black sheep of their respective and respectable families. "A. Monroe" was Abraham Rothschild, son of a wealthy jeweler in Cincinnati, whose drinking, gambling and womanizing had tried his father's patience to the point of disinheritance. "Bessie" was Annie Stone, born in 1854 to the owner of a Syracuse shoe store. She ran away from home at fifteen to be the full-time mistress of a man by the name of Moore. When they parted company, she took his last name with her and as "Bessie Moore" plied her trade as a prostitute in infamous fleshpots like New Orleans and Hot Springs.

It was at the Arkansas "resort" that Abe and Bessie met a year or maybe two before their grand entrance in Jefferson. Since his father had cut him off, Abe looked to Bessie to keep him in the style to which he had been accustomed his entire life. Given her affection for the scoundrel, she was happy to oblige but drew the line at selling her diamonds. When they fought, which had been often of late, it was over the jewels and her iron-willed determination to hold on to her prize possessions come hell or high water.

On Sunday, January 21, their third day in town, the couple decided to go on a picnic. With two fried chicken dinners under one arm and Bessie on the other, Abe strolled across the bridge over Big Cypress Creek and into the woods. He was alone when next seen in town that afternoon but made no effort to stay out of sight. In response to courteous inquiries about his "wife," he said she was visiting friends in the area and would rejoin him in plenty of time to catch the eastbound train on Tuesday.

But that was not what happened. Witnesses would remember watching "Mr. Monroe" climb onboard the train with the complete set of matching luggage the two brought with them. But no one could recall seeing the missus since her picnic departure on Sunday.

A winter storm soon blew in, dumping half a foot of snow on northeastern Texas and subjecting Jefferson to a week of subfreezing weather. When the temperature at last began to rise, Sarah King went hunting for firewood and found instead the partially decomposed body of a woman in exceptionally fine clothes. She had been sitting on the ground with her back against an oak tree when her unknown assailant fired a single bullet at point-blank range through her temple.

Even though she had been stripped of her trademark jewelry, there was no doubt in anybody's mind that the victim was the woman the townspeople had nicknamed "Diamond Bessie." Jefferson was a long way from the wild frontier (in culture as well as distance), and murder, especially of a member of the fairer sex, was not an everyday event. That may explain why the inhabitants took pity on poor Bessie and paid for her plot and burial out of their own pockets.

The "Monroes" had mentioned a short stay in Marshall prior to their arrival in Jefferson. The authorities located the hotel where the couple had spent two nights and demanded to see the register. Right there in black and white was A. Monroe's real name and his hometown. The Texas Rangers and Marion County sheriff arrested Abraham Rothschild in his Cincinnati hospital bed, where he was recovering from a self-inflicted wound. During a clumsy attempt to take his own life, the drunk had succeeded in putting out his right eye.

Meyer Rothschild may have washed his hands of his worthless offspring, but he could not sit back and allow his flesh and blood to hang for murder in faraway Texas. He financed the fight against extradition on behalf of his boy but lost that round when the governor of Ohio signed the order to send Abraham back to Jefferson on March 19, 1877.

While the wheels of Lone Star justice were famous for grinding at breakneck speed in those days, in this case they had trouble getting traction. Endless legal maneuvering by both camps and a change of venue to Marshall stalled the process for twenty months.

When the trial finally got underway in December 1878, there was hardly room for all the attorneys at the defense and prosecution tables. Papa Rothschild spent a huge chunk of the family fortune to hire the best legal talent on the market, leading one of Abe's lawyers to brag that his fee was so big he never would have to work another day in his life. Shocked by this barefaced attempt to buy an acquittal, Governor Richard Hubbard sent reinforcements to the outnumbered prosecutor in the form of two assistant attorneys general.

The courtroom drama dragged on for three long weeks, as what must have seemed like half the populace of Jefferson gave sworn testimony for and against the accused. Being an attorney himself, the judge felt obligated to let every lawyer have his say during the summation and set aside three full days for closing arguments. To no one's surprise, the dozen and a half counsels used every minute of the allotted time.

The foreman of the jury set the tone for the deliberations by sketching a passable likeness of a noose on the wall, autographing the artwork and

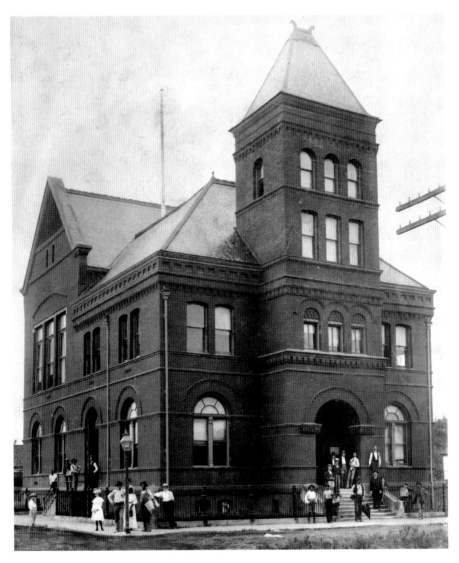

Jefferson courthouse in 1889, nine years after Abraham Rothschild's second murder trial. *Library of Congress.*

declaring the drawing his verdict. The other eleven followed suit and in nothing flat found Abe Rothschild guilty as charged and sentenced him to swing. But Abe never made it to the gallows. His conviction was overturned on appeal primarily because the trial judge had permitted a prospective juror to take a seat on the panel after stating in open court that the defendant was guilty and ought to hang.

Two years later to the month, the second trial was gaveled to order in Jefferson on December 14, 1880. The star witness for the state was Jennie Simpson, who testified under oath that she saw Abe return from the picnic without Bessie but with her diamond rings as plain as day on his fingers.

The defense counterpunched with Isabelle Gouldy, who was equally as firm in her belief that it was Bessie she saw with a strange man the day before her disappearance and four days after she was supposed to be dead. While there was neither testimony nor physical evidence to support the sighting, Abe's attorneys had planted the seeds of doubt that bore fruit during deliberations.

The jury needed only four hours to arrive at a unanimous verdict of not guilty. Flanked by his much poorer father and weeping mother, Abe Rothschild practically sprinted to a waiting carriage that took the happy trio to the train waiting to carry them home to Ohio.

Jefferson, Marion County and the State of Texas had given it their best shot and come up short. Abraham Rothschild may have murdered Annie Stone, aka "Bessie Moore," but convincing two juries of his guilt proved to be one jury too many.

In the 134 years since Rothschild's acquittal, fiction and folklore have picked up where the facts left off. Was "Diamond Bessie" with child at the time of her murder? Were a dozen $1,000 bills mysteriously lowered into the jury room during deliberations, and did all twelve recipients die under violent circumstances within the year? Did Abe Rothschild end up serving a twenty-year prison term for theft? The answer in every case is a definite "no."

It may be true, however, that near the turn of the century a man sporting a patch over his right eye showed up at Bessie's grave. He reportedly placed a bouquet of roses on her last resting place, dropped to his knees in prayer and handed the cemetery caretaker a cash incentive to maintain the grave. Some people like to think he was a guilt-ridden Abe Rothschild trying to clear his conscience.

Small Texas towns, as a rule, do not make a fuss over dead prostitutes or go to the trouble of keeping their memory alive. But Jefferson has been the exception to the rule for going on a century and a half. And every May since 1955, the local Lions Club has reenacted the "Diamond Bessie Trial" as part of the annual Jefferson Historic Pilgrimage.

CHAPTER 2
Drunk Detective Shoots Barrymore Patriarch

A falling-down drunk railroad detective went berserk in an East Texas train station on the night of March 19, 1879. Opening fire on a traveling troupe of Broadway thespians, he killed a member of the supporting cast and seriously wounded the future patriarch of the first family of the American stage and screen.

Herbert Arthur Chamberlayne Hunter Blythe was born in India, crown jewel of the British empire, halfway through the nineteenth century to well-to-do and oh-so-proper English parents. To spare his relations the shame and disgrace of having an actor in the family, he traded his mouthful of a birth name for a pseudonym that rolled off the tongue: Maurice Barrymore.

Long before he mastered his craft, English theatergoers took to the handsome young newcomer like tea and crumpets. Barrymore was not just another pretty face. He was a natural athlete with an amateur boxing championship under his belt and magnetic masculinity that set him apart from the "dandies" of the Victorian age. Audiences simply could not get enough of him.

Barrymore found stardom in America quite by chance. He was just twenty-six years old when a juicy part in a Broadway play brought him to New York in 1875 for what was supposed to be a short stay. But he proved to be such a hit that a big-time producer with his own stock company made the Brit an offer he could not refuse.

Barrymore married Georgiana Drew, a rising comedy star, and in April 1878, the couple welcomed Lionel, the first of their three famous children.

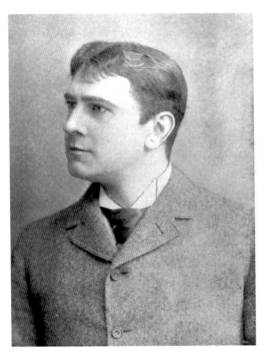

Maurice Barrymore was lucky to get out of Marshall, Texas, alive. *Library of Congress.*

But shortly before his birth, the Barrymores received a bubble-bursting piece of bad news. Their employer was filing for bankruptcy and going out of business, leaving them with a brand-new baby and no means of support.

Never one to cry in his warm beer, Barrymore bought the rights to a popular play called *Diplomacy*, came up with a partner willing to foot half of the bill and formed a touring company. In January 1879, the partner left New York for bookings in the Northeast and Midwest, followed by Barrymore's departure for Texas and scheduled stops in practically every town with a stage and footlights.

Despite the Lone Star State's reputation as a cultural desert, Barrymore and his band of greasepaint gypsies could not have asked for a better or more profitable reception. Night after night, in places they did not expect to draw flies, the troupe played to packed and enthusiastic houses.

The crowd that filled every seat in Mahone's Opera House in Marshall on March 19, 1879, was no exception. The Texans showed their appreciation by giving Barrymore and his brother-in-law, John Drew, a standing ovation for their impeccable performances in the lead roles and clapped their hands sore with curtain calls for the entire cast.

The tired but happy actors had three hours to kill before catching the late train to Texarkana, site of their farewell appearance in the Lone Star State. Ben Porter and Ellen Cummins, who had announced their engagement a few days earlier, decided to grab a bite to eat at the station platform diner, and Barrymore went along to quench his thirst.

Proprietor Nat Henry immediately waited on the first paying customers he had had in hours. While Porter and Cummins whispered sweet nothings

in each other's ears, Barrymore polished off an ale and excused himself to check on the luggage.

Moments later, a notorious bully named Jim Currie stumbled onto the premises and plopped himself down at the counter. A nasty drunk with a mean streak a mile wide, the Texas & Pacific Railroad detective had only recently killed three men under hazy circumstances, but he succeeded, as usual, in staying out of jail due to the timely intervention of his brother, Andy, the mayor of Shreveport, Louisiana.

Nat Henry dared not refuse Currie's request for a drink but cautioned, "You better go slow, Jim. You look like you've had enough."

"No, I must have some," the intoxicated tough insisted, slurring his words. "It is too good a thing around here." He nodded in the direction of the attractive actress sitting with her fiancé at a nearby table and added, "There's a high tossed whore if I ever saw one."

"Come on, Jim," the owner objected. "You don't know if she's a lady or not, and I would rather you wouldn't make any such remarks." Currie snorted, stood up on wobbly legs and stomped across the room. Pausing at the door, he suddenly spun around and accused Ben Porter of making an insulting gesture as he passed by.

The polished performer replied with his best manners, "My friend, if you alluded to me, I hadn't thought of you. I was talking to this lady here."

"You're a damn liar!" Currie growled with bulging eyes.

"I'm in company with a lady and would prefer you wouldn't make remarks of that kind in her presence," Porter protested. "If you want a difficulty, you can see me anywhere you like outside." Once again, Currie voiced his low opinion of Ellen Cummins's morals loud enough for the proprietor and Barrymore, who was in an adjacent area, to hear.

"Jim, stop that!" shouted Henry from behind the counter. No sooner had Currie turned to glare at his host than Barrymore entered the room and addressed him in a quiet, even tone: "Go away. There's a lady here."

Currie focused his wild rage on the self-assured stranger. "Maybe you want to take it up, you damned whoremonger!" Recognizing Currie for the human powder keg he was, Barrymore instructed Ben Porter to "get Miss Cummins out of here." Porter obeyed without a moment's hesitation, and the couple hurried out the front door.

"So you want to take it up?" Currie snarled, repeating his challenge. Barrymore was not the least bit intimidated by the six-foot, two-hundred-pound railroad detective's superior size. In anything remotely resembling a fair fight, his boxing skills would enable him to make short work of the drunk.

"Well, I'm not particular, but I am unarmed," the actor said taking off his coat.

"So am I," Currie lied. He was never without his matched pair of Smith & Wesson six-shooters, and tonight was no exception. Barrymore took him at his word, a potentially fatal mistake, and raised his fists in preparation for what he believed would be a bare-knuckle brawl. Currie reached inside his knee-length winter coat and came out with a cocked Smith & Wesson in each hand.

Without another word, he fired once, hitting the actor in the upper left arm. The bullet passed through the limb and buried itself in Barrymore's chest. Although badly wounded, the Englishman somehow stayed on his feet and scrambled toward the nearest exit. His attacker followed, shooting twice more but missing the mark both times. But the damage had been done, and Barrymore in his weakened state managed only a few more steps before collapsing outside.

Instead of finishing off his prey, Currie stormed back into the diner and ran headlong into Ben Porter, who had come running as soon as he heard the gunfire. Not too proud to beg for his life, Porter pleaded, "For God's sake! Don't murder an unarmed man!"

But there was no mercy in Jim Currie's heart. "God damn you!" he screamed at the top of his lungs. "I can kill the whole lot of you!" With that, he shot the paralyzed Porter in the stomach, and the slug perforated his torso, coming within a fraction of an inch of blowing out his back.

Next on the bloody scene was John Drew, frantically searching for his brother-in-law, closely followed by Ellen Cummins, who found her beloved lying in a sea of blood in the open portal. Lucky for them, Currie was done killing for the night. He pushed his way past the two dazed bystanders and out the front door, stepping over his handiwork in the process. Instead of heading for the hills, he paced back and forth on the station platform, babbling incoherently and firing his pistols into the star-lit sky.

A crowd was beginning to gather when a shotgun-toting deputy sheriff confronted a familiar troublemaker. "Jim, I've come to arrest you and take you to jail," the lawman said softly, reaching for the killer's revolvers. With drooping shoulders and a beaten look, Currie surrendered his prized possessions and muttered, "All right. I'll go with you."

The agent in charge of the Texas & Pacific Railroad in Marshall took one look at Ben Porter and Maurice Barrymore and knew that the best available medical care would be needed if they were to survive their wounds. In a matter of minutes, the first physician arrived, black bag in hand, and

put curious spectators to work turning the passenger waiting area into a nineteenth-century emergency room.

Realizing that Porter was in the worst shape, the doctor had him carried into the treatment area and his clothing removed. The instant his blood-soaked shirt was stripped away, a spent bullet popped out his back. Ben Porter died less than five minutes later without regaining consciousness.

The doctor turned his attention to the patient still clinging to life. Alarmed by Barrymore's loss of blood, which defied his efforts to staunch it, he sent runners to the homes of the town's two surgeons. After examining the actor's hemorrhaging wound, the sawbones agreed that unless they operated right then and there, he would be a corpse by morning.

The small-town surgeons saved Maurice Barrymore's life that night. They waited until sunrise to proclaim the surgery a success and to tell the rest of the troupe, already mourning the loss of one comrade, that their leading man was out of danger.

Georgiana Barrymore caught the first westbound train to be at her husband's bedside. She made amazingly good time, reaching her destination in a whirlwind three days. Her comforting presence, combined with the unstinting efforts of the residents of Marshall to make their guest's extended stay as pleasant as possible, accelerated Maurice's recovery.

Meanwhile, Marshall and the Lone Star State were taking it on the chin in the national press. Typical of the coverage was a hysterical attack in a St. Louis journal that scorned Texas as "a place where whiskey and pistols are too plentiful and law and order too scarce." Those critics overlooked the fact that newspapers throughout Texas condemned the crime and the culprit. "It is gratifying to state that Currie is not a Texan [and] not a southern man," editorialized the *Tri-Weekly Herald* in Marshall. "Like three-fourths of the murderers that have disgraced our state, he comes from abroad."

"From press and people went a shudder of horror at the crime that had stained our soil," the *Waco Telephone* concurred. "Texas disowns Currie, and the friends and companions of the murdered man have been afforded every possible evidence of the detestation entertained for the deed."

Jim Currie did nothing to improve his image or his chances in court. In a jailhouse interview, he expressed "no regret at what he had done," only that "he had not killed the entire party." He was, to be sure, a defense attorney's nightmare.

Barrymore would not have missed Currie's day of judgment for the world and dropped what he was doing to rush back to Marshall for the murder

trial in July 1879. Two other key witnesses for the prosecution were absent, however. Nat Henry had sold his diner for much more than it was worth and vanished into thin air, while Ellen Cummins had gone into seclusion in her hometown of Louisville, Kentucky, after leaving a sworn statement testifying to the events of the dreadful night that changed her life forever.

Oddly enough, it was the defense rather than the prosecution that made an issue of the missing witnesses. Judge A.J. Booty granted its request for a continuance, prompting Barrymore to remark, "This reminds me of our performances in England. We commence with a tragedy and end with a farce."

A series of cleverly conceived legal maneuvers by Currie's team of eight high-priced lawyers stalled the proceedings for almost a year. When the defense finally exhausted its bag of tricks, the judge circled June 10, 1880, on his court calendar for the trial date.

Barrymore returned again to Marshall, where he was joined by Ellen Cummins, who had been persuaded to give her tearful account from the witness stand, and Nat Henry, brought back in handcuffs from his hiding place in Fort Worth. Both the actress and the runaway proprietor overcame their initial reluctance to tell their compelling stories to a spellbound courtroom. As for Barrymore, he gave one of the best performances of his career—only this time it was pure fact, not a flight of fancy.

The "dream team" defense was left grasping at straws. At first, it claimed that Currie had fired in self-defense, a lame argument that flew in the face of the convincing eyewitness testimony. So, the legal eagles did an abrupt about-face to contend that their client had not been in his right mind on the evening of the senseless rampage.

The case, considered open and shut by all who watched it unfold, went to the jury on the eighth day. The dozen men "good and true" were back with a verdict in ten minutes. "With unabashed pride," the foreman declared, "we the jury find the defendant not guilty by reason of insanity."

The dazed supporters, who saw Barrymore off at the station, shared his disappointment and anger at the verdict. "A set of blackguards, the whole lot of them!" he roared. "From that evil looking judge downwards. They must have been squared by somebody. I guess there wasn't a man in court who wouldn't sell his soul for a whiskey sour!"

The prosecutor stated with absolute certainty his opinion that the miscarriage of justice had been bought and paid for. At least one member of the tainted jury took no pains to hide a fat wad of bills, and another cynically admitted that "he had not been on the jury for nothing."

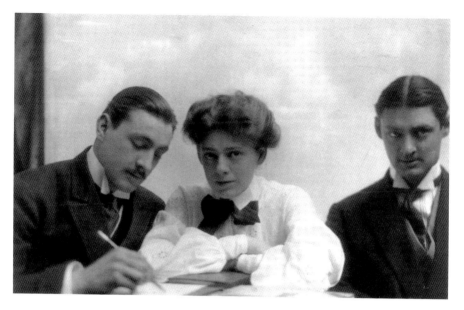

Maurice Barrymore fathered three children destined for stardom. *Left to right*: John, Ethel and Lionel. *Library of Congress.*

Before returning to his duties as mayor of Shreveport, Andy Currie sent his bad-seed brother packing. Jim did not stop until he reached New Mexico, where he went into the saloon business with a nest egg from his kin.

It was, of course, just a matter of time until the homicidal maniac killed somebody else. Brother Andy failed to bribe that jury but did succeed in arranging his early release from the New Mexico state penitentiary just two years into a twenty-year term. It took a bullet in the chest in a south-of-the-border bar to finally put an end to Jim Currie's one-man crime spree.

Before he died in 1905, Maurice Barrymore fathered two more future stars—Ethel and John. On the stage and later the silver screen, his three children carried the family name to new heights as the unofficial "royalty" of the American entertainment world before passing the baton to John's granddaughter Drew.

And it never would have happened if a drunk railroad detective had been a better shot that night in a Texas train station.

CHAPTER 3
Ex-Employee Goes Postal in the Capitol

The shocking events of June 30, 1903, may have left most Texans at a loss for words, but not an East Texas editor, who wrote, "The tragedy is the first of its kind in the history of the state and is the most appalling in the annals of the South."

Colonel Robert Marshall Love could credit his rapid rise through the ranks of the Democratic Party to his part in the dramatic removal of Governor Edmund J. Davis, the despised Radical Republican who made the lives of former Confederates so miserable during the dark days of Reconstruction. Refusing to abide by the results of the November 1872 election that swept Democrat Richard Coke into office, Davis surrounded himself with armed supporters and waited for President Ulysses Grant to call out the troops to disperse the Rebel rabble.

Even after Grant told him in no uncertain terms that the time had come to step down, Davis would not budge. When he finally chose a nonviolent departure over a fight to the death, R.M. Love and his brother provided safe conduct for the pariah.

Twenty-seven years later, the Colonel, as he was known by then, won statewide election to the important position of comptroller. On that fateful morning in the summer of 1903, Love was casually chewing the fat with a preacher from Bonham when an agitated ex-employee burst into his office in the east wing of the state capitol. The unflappable official reacted to the rude interruption with a smile, a handshake, an introduction to his guest and an invitation to sit a spell.

The cordial reception from his old boss startled W.G. Hill, who acknowledged the gracious greeting with a stiff nod and plopped down in an empty chair. Repeated attempts to include him in the conversation were rebuffed with hostile stares or terse one-word replies.

Made uncomfortable by the tension in the room, Reverend M.F. Cowden bid both gentlemen good day and rose to take his leave. He was barely out the door when Hill jumped to his feet and handed Love a two-page letter that he insisted the Colonel read right then and there. Colonel Love decided to humor the high-strung intruder and spun around in his swivel chair to concentrate on the tedious task. As he suspected, the document was the canned clerk's denunciation of his supposedly unfair firing. The out-of-work civil servant had scrawled the following:

> *Dear sir—Public office is a public trust. Public offices are created for the service of the people and not for the aggrandizement of a few individuals.*
>
> *The practice of bartering department clerkships for private gain is a disgrace to the public service and in the nefarious traffic you are a "record breaker."*
>
> *You have robbed the state's employees, and your incompetent administration has permitted others to rob the state.*
>
> *The man who, claiming to be a Christian, deprives others of employment without cause is a base hypocrite and a tyrant.*
>
> *If the host of democratic spoilsmen-politicians of this state, of the McGaughey-Love-Robbins-Sebastian-Rountree type had such a thing about them as a conscious [sic], in a healthy state of activity, they could not look a republican in the face without blushing.*
>
> *The greatest mind that ever gave its wisdom to the world; the mind of all others most capable of "umpiring the mutiny between right and wrong," said: "You take my life when you do take from me the means by which I live."*
>
> *If that be true you are a murderer of the deepest crimson hue.*
>
> *Although I can not help myself, before laying life's burden down, I shall strike a blow—feeble though it may be—for the good of my deserving fellow man.*
>
> *For the right against the wrong.*
> *For the weak against the strong.*
>
> *Yours truly, W.G. Hill*

Given the untold hours he must have devoted to writing and rewriting the long-winded attack on the Colonel's character, it was strange that Hill did not

possess the patience to let Love finish reading it. Regardless of the reason, he reached in a coat pocket, pulled out a .38-caliber revolver on loan from his son and shot the comptroller in the small of the back.

The ear-splitting roar brought J.W. Stephens, the state bookkeeper, on the run from an adjoining office. But the would-be rescuer arrived too late to prevent Hill from putting a second slug in the bleeding colonel, who had turned to face his attacker. The bullet pierced the Civil War veteran's barrel chest, ricocheted off a rib and tore through his lower torso.

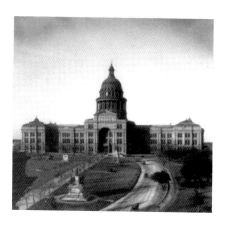

The Texas capitol in 1909, nine years after the murder of state official R.M. Love. *Library of Congress.*

Hill heard Stephens coming and whirled to welcome him with the business end of the smoking six-shooter. The broad-shouldered bookkeeper flattened Hill with a flying tackle that knocked the pistol out of his hand and sent it skidding across the freshly polished wood floor.

Reverend Cowden reentered the room to see the two men locked in a life-and-death struggle for the weapon. Transfixed by the savage scene, he watched helplessly as an anonymous hand grabbed the gun and ended the wrestling match with a third and final shot. For several suspenseful seconds, the preacher could not identify the winner of the desperate battle. Finally, to his immense relief, the burly bookkeeper rose to his feet and stood over the motionless murderer.

Hill was soon an island in a rising tide of his own blood. He rolled onto his back, revealing the source of the plum-red sea: a bullet wound in the stomach. Retrieving from his vest pocket a tiny bottle of laudanum, the most popular and widely abused drug of the day, the groaning gunman begged the bookkeeper not to interfere. "Let me take this and die easy," he whimpered. The pitiful plea fell on deaf ears, and Stephens pried the vial from his cold fingers, sentencing the assassin to a slow and agonizing death.

Colonel Love staggered to his feet and took an unsure step toward the bookkeeper and the minister. "I've been shot!" he cried out in amazement before losing his balance and falling to the floor. More accustomed to saving souls than saving lives, the good reverend did what he could to make the mortally wounded man comfortable. As Cowden placed a pillow under the

dying man's gray head, Love opened his eyes and softly said, "I am shot but it is well with me. God bless you and God bless him."

Chaos reigned in the capitol as word spread of the shooting. To accommodate the concerned and curious at the crowded crime scene, Hill was unceremoniously carried to the far side of the rotunda and left alone on a cot to wait his turn for medical attention.

The state health director examined the conscious comptroller and confirmed the worst. His wounds were fatal. Realizing that he had mere minutes to live, Love calmly dictated a deathbed declaration to his weeping personal stenographer: "I have no idea why he shot me. May the Lord bless him and forgive him. I can say no more."

Yet he managed to linger long enough for his loved ones and Governor S.W.T. Lanham to rush to his side. He extracted from the teary-eyed governor a promise to appoint the heroic bookkeeper as his replacement before taking his last breath at five minutes past eleven o'clock.

"After one unsuccessful effort to give to the world and those around him a last parting word," the *Austin American-Statesman* reported in the flowery prose of that age, "the soul of R.M. Love plumed its snowy pinions and sailed away to the pearly portals of Paradise."

W.G. Hill died four hours later in an Austin hospital, with his motive still subject to speculation. The vague reason he gave for the first and last killing in the capitol was simple and to the point: "He didn't treat me right."

Lax security was initially blamed for the incredible crime, but turn-of-the-century Texans eventually came to grips with a troubling fact of life that their modern-day descendants would be forced to face a century later: there is no bulletproof safeguard against a madman on a mission.

Blood Feud or Killing Spree?

The main characters in the tragic romantic triangle that erupted into the bloody private combat known as the Boyce-Sneed Feud grew up together in the Central Texas community of Georgetown in the late nineteenth century. The fathers of John Beal Sneed, Albert Boyce Jr. and Lena Snyder had done right well for themselves in cattle, and as successful businessmen, they provided worry-free childhoods for their respective offspring.

While students at Southwestern University, their hometown college, the two boys competed for the girl. It was Beal who won Lena's hand, a victory formalized by their 1900 wedding, and Albert Jr. had to settle for second place.

The married couple and the bachelor went their separate ways only to wind up in Amarillo ten years later. As the months went by, Albert Jr. was a frequent and welcome caller at the Sneed residence. That his visits often coincided with Beal's business trips set suspicious tongues to wagging in the small town of ten thousand, but the trusting husband was either deaf to the gossip or genuinely unconcerned.

As is so often the case, Beal Sneed may have been the last to know about the intimate nature of Lena's relationship with Al Boyce. Colonel Albert Boyce Sr. and his wife, parents of the "home wrecker," were aware of Junior's scandalous conduct as early as July 1911 and talked themselves blue in the face in repeated attempts to convince their son to break it off.

Sometime in September, Henry Boyce and Joe Beal found out about the affair that pitted their brothers and potentially their entire families against each other. At a meeting of two reasonable minds in Dalhart on October 6,

they sought the delicate but effective means to extricate their siblings from the emotionally charged mess that threatened their reputations, their honor and, if things got out of hand, their very lives. At the end of a long back-and-forth, Henry and Joe could agree on only one course of action: this was a matter for the patriarchs of the three clans.

Life on the Texas frontier had never been a bowl of cherries, and no one knew that better than Joe T. Sneed Sr.; Lena's father, Tom Snyder; and Colonel Boyce. But in this three-sided affair of the heart, the hard-bitten trio was in way over their gray heads.

Then on Friday, October 13, 1911, Beal returned home to a bombshell revelation. Lena confessed her "infatuation" with Albert and announced her intention to run away to South America with him, accompanied by one or both of their children. When the shaken Beal asked what had "come over" her, the cold reply was that she had never loved him.

Beal decided later that night that a murder-suicide was the solution to his problem. But Lena screamed at the sight of the pistol in his hand, and their nine-year-old daughter, Lenora, ran into the room and snatched the gun away from her daddy.

Beal overcame his humiliation enough to confide in his father, who gave him a sound piece of advice that would have prevented the loss of blood and lives had his son only heeded it: "Your wife has been false to you, a traitor to you, and there is not but one thing in the world you can do. Throw her out and let her go."

But those words of wisdom went in one ear and out the other. Beal refused to give up on his adulterous mate and the mother of his children. He wanted Lena back, but only after she and Al Boyce had been sufficiently punished.

Beal consulted the family doctor, who advised him "to remove his wife to the coast or a lower climate" before she completely lost her mind. Acting on the quack's recommendation, quite common in those days, he had her committed to a Fort Worth sanitarium on October 27, which just happened to be the couple's eleventh wedding anniversary.

The two brothers who operated the private mental ward catered to wealthy husbands intent on teaching disobedient wives a hard lesson. Wilmer and Bruce Allison were old hands at bypassing legal hurdles like court-ordered commitment, which could be granted only by a jury following a public hearing. The Allisons did not bother with such unpleasant technicalities and readily admitted Lena Sneed strictly on her husband's say-so.

While Beal was convinced beyond a shadow of doubt that his wife was bats-in-the-belfry crazy, he recognized the need for a concurring opinion

from a respected psychiatrist. Therefore, at considerable expense, he hired the former head of the state asylum in Terrell to examine Lena in her new accommodations with the understanding that the good doctor would live up to his ethical obligation by declaring her insane.

However, the shrink apparently disregarded his instructions and pronounced the woman mentally fit. Beal insisted on a second visit, and this time the psychiatrist fudged on his initial assessment by saying that she "might" be insane but that he could not be certain. When his employer demanded yet another examination, the weary doctor pulled a brand-new diagnosis out of his hat to get him off his back. He told Beal that his troubled wife was "morally insane." Beal liked the sound of that and sent the psychiatrist on his way.

With the aid of a sympathetic nurse, Lena smuggled a letter out of the mental institution to Albert Jr. "For God's sake!" she pleaded. "Come and take me away." He caught the first train to Cow Town and engineered Lena's escape, and the lovebirds flew north of the border.

Private detectives hired by the hopping-mad husband followed the fugitives to Winnipeg, where the cooperative Canadians jailed them as per Beal's request. Lena was released to the custody of her father and held against her will on his New Mexico ranch, while Albert Jr. remained under lock and key on a trumped-up charge.

Beal was not, however, the only Texan with money and influence. Albert Boyce Sr., former manager of the famed XIT Ranch turned gentleman banker, succeeded in having his son's slate wiped clean and persuaded his namesake to make himself scarce. The old man paid dearly for looking out for his own. On January 13, 1912, in the lobby of the Metropolitan, Fort Worth's four-star hotel, Albert Sr. was shot to death in front of dozens of eyewitnesses. And everyone who got a good look at the triggerman identified him as John Beal Sneed.

Seats were at a premium three weeks later on the opening day of the murder trial of the new century. The cavernous courtroom was filled to overflowing by newspaper reporters from as far away as New York City and female spectators, who fought with hatpins to hear titillating testimony that the judge deemed "unsuitable" for the delicate ears of the gentler sex.

Forty witnesses for the prosecution painted a graphic picture of the killing. Several recalled overhearing someone in Colonel Boyce's party, seated in the hotel lobby, remark as Beal Sneed walked past, "There goes the (several expletives deleted) now."

Seconds later, a seventeen-year-old boy asked the defendant for a light. Beal reached into his coat pocket, but instead of a matchbox, he pulled out

a .32-caliber pistol and started shooting at Albert Boyce Sr. from a distance of no more than three feet. Struck by four bullets, Boyce staggered to his feet and turned toward the elevator. Beal fired a fifth and final shot into the Panhandle pioneer's back, and he collapsed on the marble floor. Albert Sr. died from his wounds fifteen minutes later at a nearby hospital.

During his day and a half on the witness stand, Beal Sneed made no attempt to deny his guilt. He claimed to have fired in self-defense when the victim and a companion rose to their feet "as if to attack." He added that the expletive-laced comment caused him to snap. "It all came over me like a flash that this man had taken my wife from me and ruined my home and now, when I had rescued her from a life of shame, he wanted to take her away from me again."

Aghast at the jurors' inability to reach a verdict, Judge J.W. Swayne begged them to keep trying. "This case has attracted the widest attention of any case ever tried in Texas…. The world knows what the testimony is, and it has put Texas on trial." Nevertheless, the jury deadlocked seven to five in favor of acquittal, forcing the hapless judge to declare a mistrial. Beal Sneed was a free man for the time being, but the story of the Boyce-Sneed Feud was not over—not by a long shot.

The Tarrant County district attorney wasted no time in announcing that he would try Beal Sneed again for the murder of Albert Boyce Sr. But the defendant's father did not live long enough to see his son stand trial a second time. Joe Sneed was standing on the sidewalk in front of the Georgetown Post Office sorting his mail on the morning of March 6, 1912, when three gunshots rang out. Two .45-caliber bullets hit the rancher in the back, killing him instantly.

As soon as he was certain that Sneed was dead, R.O. Hilliard turned the smoking revolver on himself. A tenant farmer who had once worked for the wealthy cattleman, Hilliard had fought him over a piece of land but lost a bitter lawsuit. In the killer's pocket, the coroner found a note that Hilliard had written to his wife: "My mind has failed me. J.T. Sneed is the cause of it. I am going to take revenge this way and then go to the asylum." At the last second, he apparently changed his mind about spending the rest of his life in a straitjacket.

Although the authorities assured him that Hilliard had acted entirely on his own with no aid or encouragement from anybody, Beal Sneed found his father's slaying coming right after the Fort Worth trial just too much of a coincidence. In his paranoid state of mind, he could not help but believe that the Boyces were behind it. Friends reminded Beal of Albert Jr.'s prowess with

firearms, and a private detective hired to keep tabs on the surviving Boyce claimed that he was lurking in the shadows ready to strike. His fear fueled by these reports, Beal decided that one of them had to die.

Wearing a fake mustache, a full beard and a farmer's work clothes, Beal Sneed slipped unnoticed into Amarillo the last week of August 1912. He rented a cottage on Polk Street and patiently lay in wait for Albert Jr. On September 14, Beal finally spotted the man whom he blamed for all his troubles coming down the street. Albert Jr. rarely ventured out in public without one or more of his three brothers, but there he was, all alone. It was too good of a chance to pass up.

Beal Sneed charged out the door and with each stride closed the gap between him and his prey. Albert Boyce Jr. sensed the approaching danger and reached for his ever-present pistol, but it was too late. Three blasts from a twelve-gauge shotgun tore him apart.

In a replay of the events eight months earlier in Fort Worth, Beal calmly strolled to the county jail and turned himself in to the sheriff. His perp walk was witnessed by a twenty-four-year-old grade school teacher destined to take the art world by storm: Georgia O'Keefe.

Townspeople feared the worst, as members of the warring clans descended on Amarillo in the tense aftermath of Albert Jr.'s murder. But the combined forces of the law managed to keep a tight lid on the powder keg until Beal posted bail and left town.

That November, he was back in Fort Worth for the retrial in the killing of his latest victim's father. The proceedings took four weeks but ended abruptly when the jury voted on the first ballot to acquit Beal of the sensational crime. The feudist was on a legal roll, and few expected a conviction at the February 1913 trial in the death of Albert Jr. Right they were, as Beal left the Vernon courthouse a free man and a hero to many.

When an out-of-state reporter asked the foreman how the jury could declare a confessed murderer innocent, he replied, "The best answer is because this is Texas. We believe in Texas that a man has the right and the obligation to safeguard the honor of his home even if he must kill the person responsible." That was the end of the so-called Boyce-Sneed Feud. Back together again after all the bloodshed, Beal and Lena moved to Paducah, halfway between Plainview and Wichita Falls.

Beal Sneed finally saw the inside of a prison a decade later, when he was sentenced to a short stretch in Leavenworth for bribing a juror in a civil lawsuit. While he was behind bars, his son-in-law, Wood Barton, was shot to death by C.B. Berry over a twenty-eight-dollar debt. Shortly after his release,

Beal went looking for the man who made his daughter a widow. In March 1923, on Paducah's main street, he shot Berry twice—once in the left arm and once in the right leg, inflicting only minor wounds. Four months later, on the same street, Berry returned the favor, doing considerably more, though not lethal, damage.

Ten days after his attempt on Beal's life, a Seymour trial in the murder of Wood Barton ended in a "not guilty" verdict for Berry. Then, in early 1924, two different juries two days apart in tiny Benjamin acquitted Beal and Berry of their shootings of each other.

Beal and Lena Sneed left Paducah, much to the relief of the local inhabitants, and relocated to Dallas. Investments in the East Texas oil boom provided a comfortable living for the once notorious couple until Beal's death in 1960 and Lena's six years later.

CHAPTER 5

No Honor in Houston "Honor Killing"

Until recently, most Texans and their fellow Americans had never heard of "honor killings." This barbaric practice—which dates back to the fifth century, before the birth of Islam—is common in the Middle East, North Africa and South Asia, where punishment for this culturally sanctioned murder is normally nothing more severe than a short jail sentence.

A study a decade ago by the United Nations put the annual number of "honor killings" around the world at five thousand and cautioned that the estimate was undoubtedly on the low side. Victims are nearly always young women or girls in their teens whose conduct in the eyes of domineering male relatives is deemed to have tarnished the family reputation. Their "crimes" can be as harmless as a fondness for Western clothes and music, going out in public with a member of the opposite sex or refusing to submit to the outdated custom of arranged marriage. According to the honor-killing code, the shame that the wayward or disobedient female has brought on her family can be washed away only with her blood.

Ninety years ago in Houston, a clean-cut college boy committed a coldblooded murder in the name of family honor. His long-forgotten crime, his warped and self-serving rationalization and what happened at his trial is a story worth telling.

For all of his twenty-two years, Bob Robinson had lived the good life as the only spawn of a mighty big fish in a mighty small pond. His father was a well-to-do doctor with the most successful practice in Cleveland, a farming community northeast of Houston. When Bob went off to

college, he went in style, compliments of dear old dad, who was happy to give his son a free ride.

But in the spring of his sophomore year at the University of Texas, the checks began to bounce. For the first time in his short and affluent life, Bob reached in his pocket and pulled out nothing but spare change. Then his landlord put him on notice that he had one week to make good on his father's worthless rent check or face eviction. That was followed by the most terrible news of all: tuition for the spring term had not been paid, and he could not attend class until it was.

Bob Robinson hurried back to Cleveland to find out what was wrong and why the cash pipeline had gone dry. He drove directly to his father's office only to be informed by the nurse on duty that she had not seen the doctor in days. More concerned and confused than ever, he went to the family residence hoping to find his mother.

Mrs. Robinson was home all right. She rarely went out in public anymore because of the snickers and stares from neighbors and people on the street. When the town doctor goes off the deep end, everybody knows, and she simply could not bear it.

It took hours of patient prodding by Bob to coax the truth out of his hysterical mother. His father—the stable, upright and respected pillar of community—had fallen head over heels for an attractive young woman less than half his age. That was where all the money was going—to buy Mollie Dudley whatever her heart desired.

Bob tracked down the philandering physician and tried to talk some sense into him, but the elder Robinson would not hear of it. He bluntly told him to mind his own business and stay out of his. And, the doctor added, going on the attack, it was high time his spoiled son got off the gravy train and went to work.

The Robinson residence burned to the ground in the fall of 1923 in a mysterious fire that forced the dysfunctional family to move to Houston. While commuting back and forth to Cleveland, the debauched doctor was critically injured in a car crash, leaving Bob, who had taken a job pumping gas, as the sole supporter of the cursed clan.

On the second day of 1924, the baby-faced college dropout walked through the front door of the downtown headquarters of the Houston Police Department and into the office of the chief. "My name is Bob Robinson," he said, introducing himself, "and four hours ago I shot and killed Mollie Dudley." The announcement came as no surprise to the top cop, who had half the force out beating the bushes for the suspect. The police chief must have wished at the time that all murders were so easy to solve.

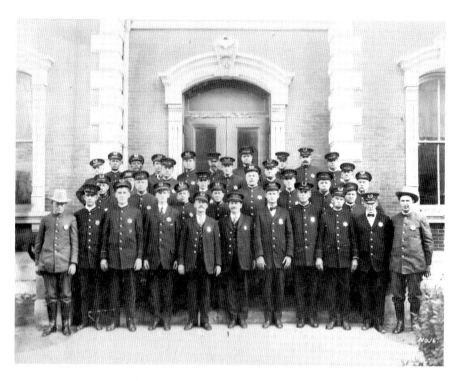

Houston policemen stand in front of headquarters four years before Bob Robinson walked through those doors and surrendered.

When the case came up on the docket in late April, Bob had not recanted a single word of the incriminating statement he made the day he turned himself in. In so doing, he had saved the jury the trouble of deciding his guilt or innocence.

At issue was his motive. Bob maintained that he killed the home-wrecker after she refused to end her affair with his crippled father, who continued to shower her with expensive gifts. The prosecutor planned to counter with the claim that the son wanted the beautiful divorcée for himself and pulled the trigger when she spurned his advances.

Failing to find a dozen open minds in a city of 175,000, the judge moved the trial to the tiny town of Kountze, north of Beaumont. A festive atmosphere prevailed on July 14, 1924, opening day of the highly publicized proceedings, with soda stands on the square and housewives hawking homemade sandwiches in the lobby of the Hardin County Courthouse.

In spite of the stifling heat inside the courtroom, sweat-soaked spectators sat glued to their seats rather than miss a single syllable of the titillating

testimony. They were richly rewarded by the opening remarks from the defense, as Bob's four attorneys, in tag-team rotation, described in shocking detail the scandalous fall of Dr. C.H. Robinson and how a conniving Jezebel had taken the old fool for his last dollar.

The leadoff witness for the prosecution was Minta Luce, proprietress of the rooming house where the killing occurred. She replayed the younger Robinson's fatal visit on the morning of January 2 and recalled hearing Mrs. Dudley loudly protest, "I wish you would leave me alone." Seconds after Luce went to fetch some firewood, three gunshots rang out. The defendant ran past the startled landlady and disappeared down the street. Luce found Mollie Dudley dead on the floor with two bullets in her heart.

Next to take the stand was Arnold Willis, Robinson's friend and co-worker. His direct testimony was dull and inconsequential, but his cross-examination was the turning point of the trial.

"Did Bob tell you that the woman he had shot had cursed him, his home, his mother and his family?" asked Judge Ned Morris, lead counsel for the defense.

"Yes," Willis obligingly replied.

"Didn't you see Bob and his mother sitting for two hours in an auto in front of the filling station crying two days before the shooting?" The witness answered in the affirmative. "Didn't Bob tell you he was telling his mother the whole story for the first time revealing the awful debauchery to her?"

"Yes." The repetitive response was accompanied by a collective gasp from the standing room–only audience.

"And didn't Bob tell you on the day of the killing that his father had threatened his mother when she talked to him about Mrs. Dudley?"

One last time, the gas station attendant answered, "Yes." The assistant district attorney, who had drawn the short straw after his boss declined to try the case, accused Willis of pulling a fast one, but the judge admonished him for "bulldozing" his own witness. The exasperated prosecutor rested, and after a quick huddle of Bob's lawyer quartet, so did the defense without calling a single witness.

"Will this jury brand this mother's firstborn a criminal and place him in a felon's cell because he was fighting for his mother?" asked an eloquent member of the defense team during closing arguments. The specter of her son behind bars provoked a piercing scream from Mrs. Robinson that prompted the judge to call a lengthy recess.

Batting cleanup for the defense, Judge Morris solemnly noted in his best preacher voice, "Divorces, high living and automobiles are wrecking too

many homes." This observation, which really had no bearing on the case, was greeted with approving nods from the packed gallery. "If the husband of this dead woman had done what he should have done," Morris thundered, "Bob Robinson would not be here now on trial for the sins of his father. There would have been a funeral procession, but it would have been from the Robinson home."

The jury found the confessed killer guilty of manslaughter and recommended a five-year suspended sentence. The judge concurred, and Bob Robinson walked out of the courtroom arm in arm with his doting mother and adoring fiancée.

The all-American boy got away with a murder motivated more by the loss of his comfortable life of privilege than the moral imperative to defend his family's "honor," and Mollie Dudley was executed for adultery. It is bad enough that this miscarriage of justice flies in the face of nostalgic notions about crime and punishment in the "good old days." Even more disturbing is the fact that almost everybody was so damn happy about it!

"First Couple" of Wichita Falls Murder Son-in-Law

The story is as old as the hills. A girl from a family on the top rung of the social ladder falls in love with a boy from the "wrong side of the tracks." Her parents object most strenuously, try their hardest to nip the juvenile romance in the bud, fail miserably in the heavy-handed attempt and ultimately abide by their daughter's wishes by learning to live with her choice.

But real life can take a tragic detour on the way to a happy ending, and that is what happened in Wichita Falls during the Roaring Twenties.

Mayor Frank Collier and his wife, Dorothy McCauley Collier, knew that their only child, seventeen-year-old Mary Frances, was dating Elzie "Buster" Robertson, nineteen. She made no secret of the relationship, which grew stronger by the day despite her parents' opposition and their demand that their precious darling stop seeing the boy from the slum the locals referred to as "No-Man's-Land."

Mary Frances understood the resistance from her mother, a stern and haughty woman who looked down her nose at everybody she believed beneath her, but her father's attitude puzzled her. After all, he had started out in the same squalor as her beloved, and look how far he had come.

Frank Collier, just like Buster Robertson, had been raised by a single mother who struggled to feed, clothe and shelter her one offspring. Long before economic necessity forced him to drop out of school after the tenth grade to find full-time employment, the boy shouldered his share of the load by delivering groceries and ice.

Collier pitched his way out of poverty, first on a semipro baseball team named the Cremos after a cigar brand and, later, as the strong-arm star of the Spudders, the club that represented Wichita Falls in the legendary Texas League from 1920 until 1932. But that was years after Collier hung up his glove and went into the clothing business. He did right well for himself, if for no other reason than people got a kick out of buying new duds from an over-the-hill sports star. And that also must have been why the voters elected him mayor in 1922.

Frank and Dorothy Collier relished their new status as Wichita Falls' "first couple" so much that they were more than willing to sacrifice the happiness of their headstrong daughter. Her infatuation with a poor boy with no prospects was simply a teenage crush, and she would get over it in time.

But the Colliers underestimated Mary Frances. True, she may have been only seventeen, but she knew what she wanted, and she wanted Buster Robertson. So, one night in June 1924, the high school sweethearts followed a North Texas tradition by sneaking across the Red River into Oklahoma, adding a couple of years to their ages, finding an obliging preacher and coming home before first light as husband and wife.

The newlyweds knew better than to share the exciting news with the Colliers. There was no telling what the mayor and his missus would do, but one thing was for sure: they would not take it well. So, on their wedding night, Mary Frances and Buster swore each other to secrecy.

As it turned out, the teenagers proved to be extremely good at keeping a secret. For the next seven months, their wedded bliss was restricted to stolen moments far from the prying eyes of the bride's ever-watchful parents.

Then came the night in January 1925 when Mary Frances's mother discovered them in bed together. With "His Honor" out of town on city business, Dorothy Collier had trouble sleeping. She roamed the house going from room to room looking for nothing in particular. Stopping at the door to her daughter's bedroom, she peeked inside and to her horror saw Mary Frances in the arms of her "boyfriend," who did not have a stitch of clothes on.

Screaming at the top of her lungs, the furious mother dragged Buster out of bed by his hair. "Wait a minute!" he protested. "I want to talk to you!" To that, the hysterical woman of the house shrieked, "I'll talk to you! Wait until I get my gun!"

Buster did not wait around to find out if she was serious. Instead, he quickly slipped on his shorts and leaped out the second-story window. He hit the ground running and was halfway across the yard before Mrs. Collier appeared at the window waving her six-shooter. Catching a glimpse of the

fleeing form, she got off a single wild shot before the two-legged target disappeared in the darkness.

Mary Frances gave her mother a few minutes to calm down before breaking the news that Buster had tried to tell her before she turned him into a clay pigeon. They had every right to cuddle under the covers, Mary Frances explained matter-of-factly, because they had been legally wed since last summer.

It was Mayor Frank's turn to learn the truth when he returned home later that day. The Colliers devoted the next month to keeping the couple at a safe distance from each other, going so far as to lock Mary Frances in her room for days on end, and to dissolving the Oklahoma marriage by filing the paperwork required for an annulment. By mid-February, the parents were confident that the tide had turned in their favor and that it was only a matter of time until the whole unpleasant affair would be over and done with.

But Mary Frances and Buster were determined to spend Valentine's Day together. When she informed her high-strung mother, Dorothy Collier came unglued and swore she would "blow his brains out" if he dared show his face.

Hoping to foil the defiant girl's plans, Mrs. Collier tricked her into going to her aunt's house, where Buster could not find her. But as soon as Mary Frances figured out what her mother was up to, she telephoned her husband to come get her. When her mother again threatened to put a bullet in the boy's head, Mary Frances had had enough. She ran out the front door and headed straight for the Robertson residence.

Meanwhile, Buster and his mother, Hattie, decided that the time had come for a heart-to-heart with the Colliers. They walked to the nearest streetcar stop and were standing on the corner when Frank and Dorothy drove past in search of Mary Frances. The mayor spotted the familiar faces, spun the car around and pulled alongside the curb in front of them. Collier exited the car to confront the mother and son. After giving Hattie Robertson a piece of his mind, he turned to his son-in-law and barked, "Buster, come here. I want to talk to you."

The boy politely obliged but a second later jumped back at the sight of the Colt .44 in his father-in-law's right hand. "Mother! He is going to kill me!" Hattie begged, "Don't kill my boy in cold blood!" but Frank Collier started squeezing the trigger and did not stop until the teenager lay lifeless in the gutter.

Bob Windham, a so-called special policeman who watched the whole thing without moving a muscle, finally intervened and took the smoking gun away from Collier. After informing the suddenly subdued mayor that he was

under arrest, Windham summoned an ambulance, but there was nothing for the attendants to do except transport the dead body to the morgue.

The shocking slaying was front-page news across the Lone Star State. One newspaper condemned the heinous crime by the "blood crazed" Collier as "another blotch on the fair name of Texas," while the *Del Rio Herald* mourned the tragic fact that "several lives are ruined and nothing accomplished for the betterment of the world."

With her grief-stricken daughter-in-law at her side, Hattie Robertson buried her boy on the Monday after his senseless Friday night murder. Mary Frances remained with Mrs. Robertson, living under her modest roof and refusing to speak to her parents on the telephone much less in person.

The writing on the wall was clear as day even to Frank Collier, and he did not bother waiting for the grand jury indictment before vacating office. But his letter of resignation was an appeal for public sympathy rather than a statement of remorse: "I am in such a torn up mental condition and worry on account of recent events and family troubles that I am in no condition to attend to the important duties of mayor."

Everyone who was anyone in Wichita Falls advised the new twenty-five-year-old district attorney to go easy on Collier. James V. Allred had little to gain and a promising career to lose by prosecuting the politically connected killer, but the youthful DA who had stood up to the Ku Klux Klan was not about to let a cheap politician get away with murder.

The trial of Frank Collier began in his hometown of Wichita Falls on March 16, 1925, a day shy of one month after his victim was laid to rest. The disgraced mayor and his legal team knew better than to dispute the facts of the open-and-shut case. All they could do was claim that the normally law-abiding pillar of the community was not in his right mind when he gunned down a defenseless boy.

The judge, in his final instructions on March 26, made it impossible for the jury to find the defendant guilty of first-degree murder. After debating the case for twenty-seven hours, the twelve citizens convicted Collier of manslaughter and gave him a token prison term of three years.

The shameful sentence brought howls of protest from the statewide press. Reminding readers of a cattle rustler recently locked up for ten years, the *Messenger* in the North Texas county of Wise concluded that "lousy calves are more essential to the peace and happiness of the people." An East Texas editor fumed that the Red River travesty showed that "life is the cheapest thing in the State of Texas" and predicted that Collier would receive "a pardon before he learns where his cot is located."

No one was more disappointed than the idealistic prosecutor, who blamed "what money and influence can do" for the miscarriage of justice. But Jimmy Allred was far from finished. Three weeks later, he stunned the local establishment once again with the announcement that he would try Dorothy Collier, not as an accessory to murder but as a co-defendant.

The DA asked for and won a change of venue to Haskell, a small county seat one hundred miles southwest of the scene of the crime. "In trying this woman," he explained to his local counterpart, "we are really trying the guilty party—rather, the guiltier. Once you see her on the stand, you will think so too. Truly, 'hell hath no fury' like her."

Hattie Robertson told her heartbreaking story to a second jury. There was not a dry eye in the gallery or in the jurors box as she recalled in excruciating detail the last moments of her beloved Buster's all-too-brief life. But the looks on the tear-stained faces changed to shock and anger when she related how the "first lady" of Wichita Falls ordered her partner-in-crime to "roll back the car and let her see that he's dead."

Dorothy Collier swore on the witness stand that she had been "joking" when she threatened to "blow Buster's brains out." She also insisted with a straight face that the bullet she fired at her son-in-law was meant only to scare him.

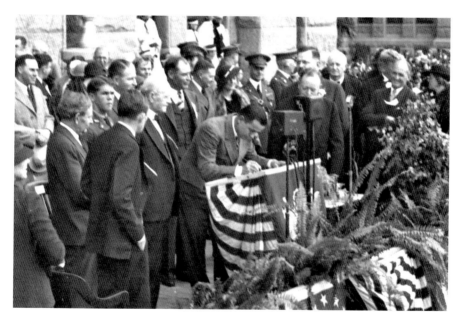

James V. Allred signs the oath of office at his 1935 inauguration and becomes the youngest governor in Texas history. *RGD0005f2473, Houston Public Library HMRC.*

In his compelling closing argument, Allred portrayed the love of Mary Frances and Buster "as pure as the driven snow on the flower-decked banks of youth." In contrast, the cruel and conniving Mrs. Collier was an "unnatural mother" and a "Lady Macbeth deserving even of the death penalty."

The judge, keenly aware of the criticism of his predecessor's conduct in the first trial, eliminated the lesser charge of manslaughter from the list of options. The jurors responded by convicting the woman of murder and sentenced her to a decade in the state penitentiary.

But in the end, it was all for naught. In November 1926, after the Colliers had run out of appeals and Frank was already behind bars, Governor Miriam "Ma" Ferguson granted them both full pardons. Famous for her "soft heart," the first elected female governor in the country took pity on the killers instead of their victim. She referred to Mrs. Collier as "that unfortunate woman" and gave Frank a pass because he "was not conscious or responsible for what he did."

On the plus side, the voters never forgot Jimmie Allred's gutsy prosecution of the couple most of his neighbors considered above reproach. In 1930, they elected him state attorney general and followed that four years later with a promotion to governor, making him, at thirty-five, the youngest in Texas history. Allred was reelected to a second two-year term and in 1949 appointed to the federal bench by President Harry Truman.

The Pistol-Packing Preacher

J. Frank Norris was Billy Graham on steroids, Jimmy Swaggart with a leash on his libido and Jim Bakker without the sticky fingers.

Decades before primetime evangelism, the charismatic pulpit-pounder was the most controversial preacher in the country. Shuttling between two huge churches in Texas and Michigan, Norris still found time to hold record-breaking rallies, host a nationwide radio show and lead zealous political crusades. The Fort Worth–based Baptist gave no quarter and asked for it only once—when he stood trial for his life.

Despite harsh and often brutal treatment, Frank Norris worshipped his father, an alcoholic sharecropper who moved his dirt-poor family from Alabama to Central Texas in 1888. At fifteen, he risked his life to help his dad fight off several attackers, who shot the brave boy three times. Temporarily paralyzed by the bullets, he spent two long years in a wheelchair before finally walking again.

The generosity of a country doctor made it possible for the underprivileged youth to attend Baylor University at nearby Waco. He burned the candle at both ends as a full-time student and pastor of a rural congregation.

In his undergraduate days, Norris spearheaded a student uprising that forced the Baylor president to resign. Infuriated by a barking dog that pranksters had smuggled into the chapel, the angry administrator threw the animal out a third-floor window. That temper tantrum ended up costing him his job.

Obtaining degrees from Baylor and a Kentucky seminary, Reverend Norris began his ministry in Dallas. In 1910, he got his big break—a call

from the First Baptist Church of Fort Worth. At age thirty-three, he became the highest-paid preacher in the South.

Norris's spellbinding sermons and unorthodox methods offended some churchgoers, but hundreds more packed his Sunday services. Over the

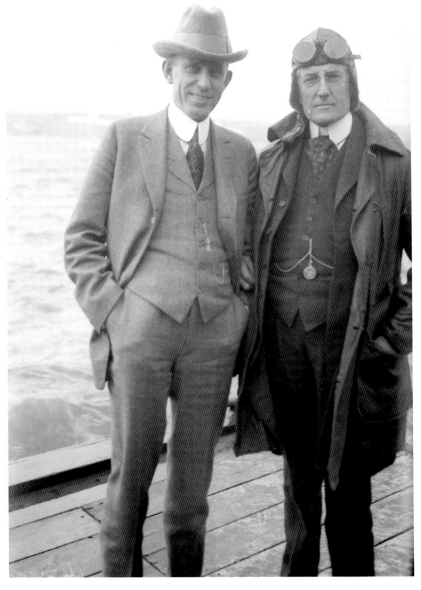

J. Frank Norris (left) showed no mercy in his fire-and-brimstone crusades. *Library of Congress.*

next eighteen years, membership increased tenfold from 1,200 to more than 12,000.

No one ever knew what to expect at Fort Worth First Baptist, where Norris regularly resorted to theatrics. During the baptism of a famous cowboy, his horse watched from the wings. At the height of the debate over Darwinism, he paraded monkeys and apes past the pulpit so the faithful could meet their "kinfolk." Norris grabbed a share of the national attention surrounding the "Scopes Monkey Trial" in 1925. His famous characterization of evolution as "that hell-born, Bible-destroying, deity-of-Christ-denying, German rationalism" was a call to arms for creationists before that term was even coined.

The militant minister combined scripture with sensational attacks against leading citizens suspected of wicked conduct. A 1911 sermon entitled "The Ten Biggest Devils in Fort Worth, Names Given" provoked an unsuccessful attempt by local officials to run the hard-hitting preacher out of town.

A few months later, a suspicious fire burned his church to the ground. Convinced by the district attorney that Norris had torched the place to obtain new accommodations, a grand jury indicted him for arson. The evidence was weak, and as expected, the trial ended in an acquittal.

Rather than mend his maverick ways, Norris doubled down. In a series of sermons in 1926 with the catchy title "Rum and Romanism," he accused Mayor H.C. Meacham of involvement in a clandestine conspiracy "to elect a Catholic president and overthrow this government." He followed that with inflammatory claims that the mayor illegally diverted taxpayer funds to Catholic organizations and engaged in sexual improprieties.

That was the last straw for Meacham, who took out his frustrations on eight employees of his department store identified as members of his tormentor's flock. He called them into his office on July 9 and told them to choose between their jobs and Frank Norris. Six of the eight stayed steadfast in their loyalty to the flamboyant fundamentalist and were fired on the spot.

The cause of the "Meacham Six" escalated the war of words that was turning Fort Worth into a battlefield. Frank Norris fired the next round in his Sunday evening sermon carried live by the church-owned radio station and heard across the South on a network of Bible Belt affiliates.

After condemning the mayor for the vindictive dismissals, Norris got personal. Holding up a photo of Meacham with a beauty pageant contestant, the reverend roared, "The man who occupies the high position of mayor of the city of Fort Worth has no business having his picture taken with his arms around young women who are dressed in one-piece bathing suits."

He waited for the deafening applause to die down before continuing the attack. "It is a matter of record that H.C. Meacham had to pay to one of his employees—a young lady—$12,500 and he gave the lawyers $10,000 besides to settle it." The shocking revelation caused the congregation to gasp in unison. "There is no dispute about it. It is a matter of court record. And if he wasn't guilty as hell, why did he pay it?"

For a solid week, the charges were repeated in print in the daily editions of the *Searchlight*, the First Baptist's publication, with a paid circulation of fifty thousand. By Saturday afternoon, July 17, Mayor Meacham was so upset and overwrought that a close friend feared he might lose his mind.

Dexter Elliott Chipps, who preferred his initials, was fuming after visiting Meacham at his store. The more the lumberman thought about it, the more he became convinced that someone had to set the high and mighty preacher straight. Instead of storming into Norris's inner sanctum unannounced, Chipps phoned ahead to let him know he was coming. The minister could not place the name, but L.H. Nutt, a church deacon who happened to be in his study at the time, said he knew the caller slightly.

According to subsequent statements from Norris and Nutt, Chipps dispensed with the usual pleasantries. "I've got something to say to you and I mean it," he said to the minister behind his desk. "If you say anything more about my friends, I'm going to kill you."

Asked by Norris to name the men he sought to protect, Chipps listed four public servants, starting with the embattled mayor. Sensing that the uninvited guest was ready to explode, the reverend cut the conversation short. "I don't want any trouble with you. There's the door."

D.E. Chipps turned to leave, but Frank Norris just had to have the last word: "I repeat everything I have said." The remark sounded like a taunt, and that was enough to set Chipps off. The look on his face and his two quick steps back toward the desk caused Norris to fear for his safety, or so he would claim on the witness stand. The man of God pulled open a desk drawer, retrieved his loaded pistol and shot D.E. Chipps three times. In no more than ten seconds, the detractor was dead.

J. Frank Norris at first presumed that he could explain everything away and be home in time for dinner. But the chief of police had other plans for the "shooting salvationist" that included arrest, a murder charge, formal booking and bail.

Even after a grand jury indicted him for homicide in the first degree, the minister did not quite understand the pickle he was in. Norris's lawyers had

to tell him over and over again that there would be an honest-to-goodness trial and that, if convicted, he faced death in the electric chair.

Everyone felt that the biggest trial in the history of Fort Worth belonged in Fort Worth. The district attorney, the defense and the judge tried to make it happen in November 1926 but never reached first base.

On the opening day of voir dire, a plain-spoken potential juror described the mountain they had to climb: "People are so prejudiced that it would be dangerous to try him in this county. There are people who dislike him so much that they would hang him if he were innocent, while there are others that would clear him if he were guilty."

The judge discounted the astute analysis as the irrelevant point of view of one ordinary man. But a poll of a three-hundred-man pool changed his mind in a heartbeat. Asked to raise their hands, if they had formed an opinion regarding the guilt or innocence of Cow Town's best-known citizen, nine out of ten signaled their inability to be impartial.

The deflated judge declared a mistrial and informed both sides that it was up them to agree on a mutually satisfactory location for the trial. The defense ruled out Houston, Dallas and San Antonio because too many Catholics lived in the state's three largest cities for their tastes. That left Austin. The capital could not have been better for the defendant. His legal team pieced together a jury willing to give the controversial lightning rod a fair hearing and to consider self-defense a reasonable defense. So reasonable was the jury that it took just seventy-four minutes to find Norris not guilty of murder.

The coldblooded killing of D.E. Chipps turned out to be nothing worse than a minor setback for the fire-breathing fundamentalist. Utilizing his tabloid newspaper and radio program, Norris expanded his influence far beyond the borders of Texas and the Deep South. Midway through the Depression, the *Searchlight* boasted the biggest circulation of any religious publication in Dixie, and a network of twenty-seven stations broadcast his weekly radio message to a coast-to-coast audience.

In 1934, Norris had begun commuting by plane between his Fort Worth church and another in Detroit, Michigan. When the total membership topped twenty-five thousand a dozen years later, he bragged that he presided over "the largest congregation ever under a single pastor in the history of the church."

As the Cold War heated up following World War II, Norris concentrated on the communist menace. In an April 1949 speech to the Texas legislature, he argued that academic freedom was "a dishonest thing" that gave cover to commie professors on college campuses.

With politics taking up more and more of the aging evangelist's time, the Detroit congregation voted three thousand to seven to hire a replacement. This public repudiation cut the thin-skinned Norris to the quick. He also resented the 1951 invasion of his home turf by a popular young Baptist whose revivals were drawing enormous crowds. "I am very happy over Billy Graham's coming," Norris said with unmistakable spite, "because he is preaching the same gospel I preached before he was born."

The next year, J. Frank Norris dropped dead of a heart attack at seventy-four. Followers mourned the loss of the Almighty's right-hand man, and critics breathed a sigh of relief.

CHAPTER 8
Seventh Time the Charm for Wife Killer

S ome men stick to the straight and narrow merely because temptation never crosses their path. Amarillo attorney Arthur D. Payne was just such a man, a churchgoing pillar of the community smugly certain of his moral superiority and contemptuous of those weaker creatures sucked into the cesspool of sin.

Then one day in the fall of 1929, fate put the forty-year-old criminal lawyer to the test. A beautiful blonde named Verona Thompson answered his help-wanted ad for a secretary, and he hired her on the spot. The attractive young woman knew that her looks had landed her the job and so did her employer, although weeks went by before he faced up to that fact.

While dictating a letter a little after Thanksgiving, Payne blurted out, "I love you!" Verona scribbled the astonishing announcement on her notepad, did a dumbfounded double take and looked up in wide-eyed surprise.

"It slipped out," stammered the tongue-tied attorney. "But I mean it, Verona. I've fallen in love with you."

The object of his infatuation confessed her feelings and burst into tears. "I know your wife. She'll never give you a divorce."

"She'll have to," Payne said firmly. "A man has a right to live." But he knew Verona was right. Eva Payne believed in the "until death do us part" portion of the marriage vow and would never consent to a legal breakup. Contested divorces were hard to come by and even harder to live down in the 1920s. How many clients would the small-town attorney have left if he walked out on his faithful mate and their three children?

It took strait-laced Arthur Payne less than a month to decide that the little woman had to die. He insured Eva's life for $20,000—more than enough to set up housekeeping with the new Mrs. Payne—and began planning her demise.

Separate bedrooms, tightly shut windows and a gas jet were the ingredients for the first attempt on her life, which occurred during the Christmas holidays. Payne retired for the night, expecting to awake the next morning a merry widower, but Eva survived and blamed herself for absent-mindedly leaving on the gas.

Payne eagerly awaited the next opportunity, which came one morning in February 1930 when Eva stayed in bed with a bad cold. After getting the kids off to school, the concerned husband gave his unsuspecting spouse eight morphine tablets dissolved in a glass of orange juice. Eva drank the lethal mixture and quickly fell into a deep sleep.

Payne monitored her vital signs late into the evening. He was encouraged by her slow and erratic pulse, but her heart was still beating when he nodded off at 2:00 a.m. Four hours later, Eva suddenly regained consciousness. The pesky cold was gone thanks to her wonderful hubby's home remedy.

Verona, who had no idea what her lover was up to, was growing impatient. Payne begged for more time, claiming that his wife was on the verge of agreeing to a divorce, while in reality he had not mentioned the matter.

The homicidal husband's next brainstorm involved a lookout at a nearby lake. He would entice Eva to the site with the promise of rekindling their romance and push the car over a cliff with her inside. Everything went according to plan, until Payne tried to send his trusting bride plunging to her death. The car would not budge, and with good reason. Eva had shifted the transmission—that he had deliberately left in neutral—back into gear.

Ten days later, Payne booby-trapped the broom closet with a shotgun, but Eva escaped with only a flesh wound to her right hand. A fiendish scheme to strand her in front of a speeding train failed because the incompetent killer ran out of gas five hundred feet from the railroad crossing. The intended victim unwittingly foiled the sixth attempt on her life by removing an electric heater from a precarious perch above the bathtub.

Each bungled murder attempt gave Payne the opportunity to reconsider his fiendish plot. Nonetheless, after six failures in as many months, he was more determined than ever to rid himself of the old "ball and chain" and to collect the insurance money.

Even the proverbial cat has only so many lives, and Eva Payne ran out of hers on June 27, 1930. Arthur announced over breakfast that he felt like walking the five miles to his law office from their home in the most

fashionable neighborhood in Amarillo. He would leave Eva the family car so she could go shopping downtown for their upcoming vacation. Then, as an afterthought, he added that he was taking the younger of their two daughters to work with him.

The other Payne girl had a play date that morning, leaving eleven-year-old Arthur Jr. to keep his mother company on her shopping spree. Ten blocks from home and within sight of the tallest buildings in town, the two-door coupe suddenly filled with smoke. Before Eva Payne could pull over to the curb, a thunderous explosion ripped the automobile apart.

The housewife died instantly, her spine laid bare by the force of the blast that blew her lifeless body half a football field down the street. The twisted wreckage of the late-model vehicle rocketed high into the air and scored a direct hit on a residence on its return to earth. No one was at home at the time, but the house was badly damaged.

As for Arthur Payne's namesake, the boy was blown clear by the explosion and landed unconscious in a front yard. Shrapnel had shredded him from head to toe and left an arm dangling by muscle and skin tissue at the shoulder. Doctors did not expect him to live through the night, but Arthur Jr. made liars out of them and eventually recovered from his horrific injuries.

The authorities bought the grieving husband's elaborate story that an unknown assassin had made good on a death threat but killed his poor wife by mistake. But Gene Howe, editor of the *Amarillo News-Globe*, smelled a rat and assigned a team of his best reporters the task of looking under every rock in Arthur Payne's supposedly upstanding life.

Even though Amarillo had nearly tripled in size over the past decade to a population of forty-three thousand, making it the largest community in the Texas Panhandle, it was in many ways still a small town. Everyone knew everybody else's business, and secrets were hard to keep, especially from experienced newshounds who knew what questions to ask.

It did not take the *News-Globe* sleuths all that long to uncover several troubling truths about Arthur Payne. For example, in recent months he had earned a reputation around town as a womanizer. As it turned out, the lawyer was not only having a hot-and-heavy affair with his stunning secretary, but he was also bedding every woman who would give him the time of day. In addition, it was common knowledge in certain criminal circles that Payne routinely profited from the felonious activities of his clients.

Nevertheless, the wife killer would have gotten away with murder had he only kept a tight rein on his ego. But that was asking too much of the arrogant lawyer, who recklessly overplayed his hand the month after the bombing.

Payne strolled into the offices of the *News-Globe* in late July and beseeched Editor Howe to take an independent look at his wife's murder. The sheriff and police departments had hit dead ends in their respective investigations, and the widower feared that Eva's killer might never be brought to justice.

Howe, who must have appreciated the irony of the situation, promised to do everything in his power to crack the case. Payne expressed his gratitude and took his leave, confident that he had pulled the wool over the eyes of the hard-boiled newspaperman. Howe immediately wired an urgent request to the *Kansas City Star* for the temporary services of the big-time daily's ace investigative journalist. A.B. MacDonald was on the next train to Amarillo. The *News-Globe* staff had done the time-consuming spadework for MacDonald. All that remained for him to do was to put the pieces together, and he accomplished that in less than seventy-two hours.

On the morning of August 5, Howe and MacDonald presented their findings to the mayor and district attorney. The bombing that had stumped local law enforcement had been solved by the Amarillo newspaper, with a helping hand from an out-of-town reporter. A warrant was issued for the arrest of Arthur Payne, and he was picked up that evening, along with Verona Thompson, who was held as a material witness but later released without charges.

When taken into custody, Payne had two identical handwritten letters on him stamped, sealed and ready to mail. One was addressed to the sheriff and the other to the chief of police. In both letters, an anonymous underworld informant claimed that Eva Payne had been killed by mistake by "a gang of safe blowers," who rigged the wrong car with dynamite. It was, of course, yet another example of the full-of-himself lawyer overplaying what had become a losing hand.

The top priority was to keep Payne alive so he could stand trial. Anticipating an angry and possibly violent reaction to the big break in the case, the sheriff and his deputies hustled their prize catch out the back door under the cover of darkness and drove him the fifty-five miles to Pampa, where a cell was waiting in the Gray County Jail.

As soon as tempers cooled and the danger of a lynch mob had passed, Payne was brought back to the Potter County lockup in his hometown. Confronted with the overwhelming evidence of his crime, he cracked like an egg and put it all down on paper in an epic confession that ran sixty-three pages.

Over the objections of his brothers, who tried to talk him into an insanity defense, Payne declared that he would plead guilty at trial and demand an expedited execution. There was no use waiting around to make "Old

Sparky's" acquaintance. But Arthur Payne had no intention of going to the chair. On August 29, 1930, the day the grand jury indicted him for the murder of his wife, he broke down after a brief visit from his older daughter and crippled Arthur Jr. Then, a little before midnight, he told his nine cellmates "good night" and went alone to an empty cell on the next floor.

Fifteen minutes later, Arthur D. Payne blew a hole in his chest with dynamite smuggled into the county jail. Death was instantaneous.

The same sheriff who never figured the prominent attorney for a murderer was once again "at a loss." He did not have a clue how Arthur Payne got ahold of enough explosive to end his miserable life, and the source of the dynamite remains a mystery to this day.

West Texas Murder Mystery Baffles Lawmen

Hazel Frome, forty-six-year-old wife of a power company executive, and her daughter, Nancy, twenty-three, arrived in Texas' westernmost town on March 25, 1938. The women were driving cross-country from their home in Berkeley, California, to Parris Island, South Carolina, to visit a second daughter and her husband on active duty with the Marine Corps.

Nancy's showroom-new Packard, a college graduation present, developed engine trouble in the New Mexico desert. Instead of sitting in their room in the Hotel Cortez waiting for it to be fixed, the two tourists took in the sights of El Paso and its sister city, Juarez, Mexico. The car was ready to go on Wednesday, March 30. The Fromes picked it up at the repair shop, asked for directions to Dallas and resumed their transcontinental trip.

On the afternoon of the following day, March 31, two army surveyors chanced upon the abandoned Packard parked on the side of the road eleven miles west of Balmorhea. The soldiers recognized the luxury sedan as the same car they had seen in the same exact spot twenty-four hours earlier. They reported the puzzling sighting to their sergeant, who phoned the office of the Reeves County sheriff.

The two deputies sent to the scene could not even hazard a guess as to why the owner of such a high-priced automobile would leave it unlocked and with the keys in the ignition in the middle of nowhere. Rather than risk taking the blame for the inevitable theft of the cream-puff, the deputies drove the Packard into Balmorhea and immediately contacted Sheriff Louis Robertson at his Pecos headquarters.

Robertson made the trip, short by Far West Texas standards, to Balmorhea the next day, Friday, which happened to be April Fools' Day, to have a look-see for himself. Other than minor scratches from an apparent joy ride through cactus country, the car was in mint condition, without the slightest sign of a struggle or foul play. However, the absence of luggage and personal belongings did suggest that it had been picked clean.

All the rural cop had to go on was the California license plate, which fortunately was still attached to the bumper. But that turned out to be enough, and by the end of the day, he had the names of the Frome women and their travel plans, as well as a hysterical husband and father, who jumped to the conclusion that his wife and daughter were dead.

With scarce resources and a chronic shortage of manpower, county sheriff in the sparsely settled expanse of Far West Texas has always been a do-it-yourself kind of job. Bright and early on Saturday, April 2, Louis Robertson filled up the Packard and drove in reverse the route the missing Fromes had taken. He stopped at every gas station, café and tourist court between Balmorhea and El Paso to ask if anyone remembered seeing the car or the women riding in it. No one did.

The banner headline on the Sunday edition of the *El Paso Times* broke the story: "El Paso Women Visitors Disappear—Mother, Daughter from California Objects of Search." And what a search it was, as all available law enforcement personnel were reinforced by volunteers on foot and horseback, cowboys, soldiers and workers on the payroll of the Civilian Conservation Corps.

Even with "eyes in the sky" compliments of the Coast Guard, there was no progress in the unprecedented manhunt until a truck driver came forward with a clear recollection of a roadside incident the day the women disappeared. He led a posse to where he had seen the Packard and a smaller automobile parked just off the highway east of Van Horn. Searchers followed two sets of tire tracks a thousand yards into the sagebrush and straight to the bodies of the missing women. Both had been badly beaten, shot in the head and laid side by side facedown in the sand. Much of their clothing had been removed, but autopsies would show that neither victim had been sexually assaulted.

The bodies bore signs of torture. "The flesh looked like it had been bitten from the forearm of Mrs. Frome," read the coroner's report. He added that her daughter's "right hand was seared to the bone by flame or embers from a burning cigar or cigarette."

The day after the gruesome find, Governor James V. Allred offered a $1,000 reward for the arrest and conviction of the persons responsible for the heinous crime. He did so in part "because it is the second instance in

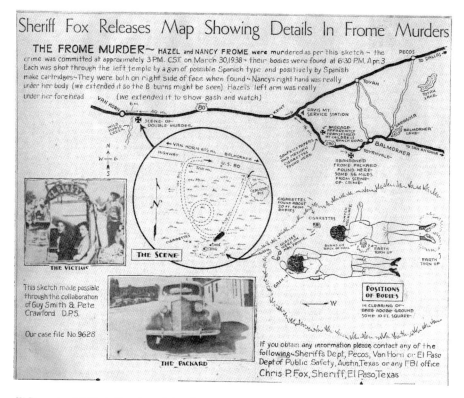

El Paso sheriff Chris Fox shared details of the manhunt for the Fromes' killers with the public. *Dolph Briscoe Center for American History, University of Texas Austin.*

recent years of the disappearance of motorists in that area of the state." The governor was referring to two couples from Illinois last seen in Albuquerque in May 1935. Their car turned up in Dallas weeks after the foursome vanished without a trace.

Half of the Texas Rangers joined the highway patrol and the sheriffs of the far western counties in the all-out search for the killers. Motorists gave them descriptions of a car that seemed to be following the Fromes on that fateful day. The number of occupants ranged from two to four, but the witnesses all agreed that one of the suspects was a woman with blond hair.

It was the sighting of a "nervous blonde" at Sonora that caused the El Paso sheriff to jump the gun on April 9. "I believe we have located the trail of the killers for the first time since the bodies of Mrs. Frome and Nancy were left on the desert," a confident Chris Fox assured an army of newsmen. But the female and her male companion somehow slipped through the borderland dragnet.

Other blondes were the source of similar false alarms. A yellow-haired hitchhiker was hauled in for questioning at Temple but let go after convincing authorities she was thumbing her way to San Francisco. The report of a blonde passing through Carrizo Springs resulted in the emergency closure of all roads in and out of Laredo.

Homer Garrison, DPS director and head of the Rangers, predicted that the Frome case would not be solved until somebody talked. *Cattle Raisers Museum.*

From the start, most investigators felt that the Fromes were the target of a random robbery that got out of hand. However, the fact that a diamond wristwatch and a gold wedding band were left behind caused some lawmen to theorize that the women were mistaken for drug smugglers and tortured to divulge the hiding place of their dope.

As the investigation dragged on, new theories were presented by the hard-pressed sheriff of El Paso. For a time, he argued that the brutality of the slayings suggested a crime of passion, most likely revenge killings committed by somebody from California known to the victims. Then he briefly tossed around the idea that the Fromes might have met their murderers in a Juarez bar. But after a while, even Sheriff Fox ran out of straws to grasp.

The closest Lone Star lawmen came to cracking the case was the 1943 extradition of two men and a woman from California and the arrest of another woman in Mexia. Charges were filed for the first and last time only to be dropped after everybody's story checked out.

In a 1953 interview, Colonel Homer Garrison, head Ranger and director of the Department of Public Safety, stated for the record that Texas' most baffling murder mystery of the twentieth century would not be solved until someone finally talked.

As the years went by without a hint of a remotely relevant clue, the Frome torture-murder slowly slipped the public's mind and became one more forgotten "cold case." The newspaper column I wrote in 2008 for my series "This Week in Texas History" was the first time the tale had appeared in print in three decades or more.

Then, in 2014, along came Clint Richmond with his impressively researched book *Fetch the Devil: The Sierra Diablo Murders and Nazi Espionage in America*. The former journalist, who cut his teeth on the Kennedy assassination and the trials of Jack Ruby and Billie Sol Estes, puts forth the intriguing theory that Hazel and Nancy Frome accidentally fell into the clutches of Nazi spies working out of El Paso on the eve of World War II.

Does Richmond have it right? Has he solved Texas' biggest murder mystery of the twentieth century? After seventy-five years, *Fetch the Devil* is at the very least a step in the right direction.

CHAPTER 10
"Phantom Slayer" Terrorizes Texarkana

In February 1946, the American people were preoccupied with welcoming home the soldiers, sailors and Marines who had won the Second World War and lived to tell about it. Everyone, civilians and veterans alike, had one thing on their minds: getting back to a normal life as quickly as possible.

The twenty thousand inhabitants of Texarkana, the town that straddles the Texas-Arkansas line in the northeastern corner of the Lone Star State, were no different. And "normal" for the younger crowd meant finding romantic spots where they could be alone.

On the night of February 22, 1946, Jimmy Hollis and Mary Jeanne Larey, ages twenty-three and nineteen, parked on a secluded road alongside Spring Lake Park, a lovers' lane popular with local youth. In the distance, they could hear the traffic on busy Highway 67, which stretched from St. Louis to Little Rock and changed course at Texarkana for Dallas, where it wound its way south to Presidio on the Mexican border.

Jimmy and Mary Jeanne had been talking quietly for five or ten minutes when a masked male figure suddenly appeared at the driver's door. Shining a flashlight in their eyes, he ordered the blinded couple out of the car at gunpoint.

Hollis was told to unfasten his belt and drop his pants. The instant he did so, the attacker hit him on the back of the head with a pistol, splitting his skull and fracturing most of the vertebrae in his neck. The young man collapsed in an unconscious heap on the gravel-covered dirt road.

The mystery man turned to face the defenseless teenage girl. He pointed up the dark lane and uttered a one-word command: "Run!" Mary Jeanne did

indeed run for her life, but she was no match for the physically fit attacker. He easily caught up with her and, with one blow, knocked her down in the middle of the road. He jumped on top of Mary Jeanne and started tearing at her clothes. Just then, an automobile came around a curve and turned night into day with its headlights. The surprised assailant was gone in a flash, and the bruised and battered girl stumbled into the woods, where she waited until she was certain the monster was gone.

The flickering lights of a farmhouse served as a beacon for Mary Jeanne, who bravely followed them to safety. Fortunately, the family was home and cared for her as best they could until the sheriff's department arrived. Deputies followed her directions to her date's last known location and found Hollis where he had fallen, still out like a light.

When Jimmy Hollis finally regained consciousness in the hospital the next morning, he could add little to what Mary Jeanne Larey already had told authorities, and that was not much. Complicating the case was the fact that the couple contradicted each other. Hollis thought the suspect was white, while Mary Jeanne remembered him as black, and neither could provide a physical description—not even height or weight. In short, Texarkana lawmen had next to nothing to go.

At this critical juncture, the sheriff and police departments made a controversial call that would come back to haunt them. Convinced that premature press coverage would cause unnecessary concern in the community and decrease their chances of catching the culprit, they decided to keep a tight lid on the terrifying story.

A month and two days later, on March 24, the bodies of a twenty-nine-year-old man and his seventeen-year-old female companion were discovered not far from the site of the first attack. Richard Griffin and Polly Ann Moore both had been shot twice in the head with a .38-caliber handgun.

This time, the gruesome news could not be suppressed, and a morbidly curious crowd overran the crime scene, obliterating all clues before the unprepared police could comb the area. To make matters worse, the hasty embalming of the girl's remains prevented important postmortem tests.

In the hope that more experienced sleuths might save the day, Texarkana authorities called in the Texas Rangers to clean up their mess. A crack team of khaki-clad state cops led by Captain Manuel T. Gonzaullas, the legendary "Lone Wolf," rushed to town and tried, without much success, to make sense of the two contaminated crime scenes.

Although he was only two years away from retirement, Gonzaullas was still at the top of his game. The first Ranger with a Spanish surname—the reason

Captain M.T. "Lone Wolf" Gonzaullas (right), first Texas Ranger with a Spanish surname, took charge of the "Phantom Slayer" case. *RGD0005f3843, Houston Public Library HMRC.*

why many Texans presumed he was of Mexican descent—Gonzaullas was actually a native of Spain. He earned his famous nickname in the bloody oil boomtowns and the lawless borderland of the 1920s and 1930s due to his hazardous habit of going up against dangerous characters without backup.

Gonzaullas and his brother Rangers offered to stay indefinitely in order to lend a hand, but wounded pride and their sullied reputation caused the local cops to refuse the expert assistance. That would turn out to be another bad decision they would live to regret.

Meanwhile, mounting hysteria gripped Texarkana. Critics of the besieged police charged that two lives might have been saved by public disclosure of the initial incident. Within hours, merchants completely sold out of firearms, ammunition and heavy-duty door locks as citizens fortified their homes and businesses against the murder menace the *Texarkana Gazette* dubbed "The Phantom Slayer."

Three weeks to the day after the double homicide, two high school students selected Spring Lake Park for a late-night tryst despite the tidal wave of warnings. Slain in the same execution style, they were found dead the next morning. The grisly killings made sensational front-page copy across the country as a pack of reporters descended on the stunned town. As if the facts were not lurid enough, newshounds started a nerve-wracking countdown to the anticipated date of the next murder.

Texarkanans lived on a steady diet of raw fear, which escalated into mass paranoia. A Western Union messenger boy narrowly avoided an early grave when a trigger-happy telegram recipient mistook him for "The Phantom." Visitors were advised for their own protection to clear the streets by twilight, and Texarkana after dark turned into "the Town that Dreaded Sundown," the title of the 1977 motion picture inspired by the events of 1946.

Captain Gonzaullas eventually returned and took charge of the investigation. On occasion, his pull-no-punches approach may have added fuel to the paranoia bonfire. In a radio interview, he recommended that listeners "oil up their guns and see if they are loaded. Put them out of the reach of children. Do not use them unless it's necessary, but if you believe it is, do not hesitate."

More than one thousand suspects were questioned and every plausible lead exhausted. Police decoys, with one of the two plainclothes officers disguised as a woman, were stationed nightly at isolated locations, but "The Phantom" did not take the bait.

On May 3, 1946, forty-eight hours before the news media's deadline, the serial killer set his sights on a couple in the Arkansas countryside ten miles northeast of Texarkana. Virgil Stark was relaxing in his recliner listening to the radio when a bullet crashed through a window, killing him instantly. His horrified wife ran to the telephone but was shot twice in the face before she could finish dialing. Incredibly, she summoned the strength to stagger

outside and make her way to a neighbor's house. Even more amazing, Mrs. Stark recovered from her wounds.

Four days later, the corpse of an unidentified tramp turned up along a stretch of railroad tracks on the outskirts of Texarkana. In all likelihood, he was a drifter whose only crime was hopping one freight train too many. Nevertheless, many emotionally drained inhabitants convinced themselves that the unclaimed corpse was that of "The Phantom."

"Lone Wolf" Gonzaullas never shared that overly optimistic opinion. After his retirement in 1951, he disclosed that his investigation had yielded a prime suspect but not enough evidence for arrest and prosecution. The famous Texas Ranger implied that the Phantom Slayer was alive and well and walking the streets of Texarkana.

CHAPTER 11
Scandalous Death for Firefighting King

With a mixture of excitement and dread, the rookie sheriff of Potter County drove out to the Route 66 tourist court on the east side of Amarillo on the morning of June 23, 1949. Paul Gaither had seen his share of human remains in his years of enforcing the law, but judging from the call from the motel clerk, who babbled incoherently about "all the blood" in cabin 18, this was not a case of some guest passing away peacefully in his sleep during the night. It sounded like a homicide, and if so, it would be Gaither's first since pinning on the sheriff's badge.

By the time Gaither arrived at the Park Plaza Motel, a larger than usual swarm of the morbidly curious had already assembled. Pushing his way through the milling crowd, the sheriff spotted a number of familiar faces belonging to reporters from the three daily newspapers, whom he expected to be there, and members of a local riding club called Will Rogers Range Riders, whom he did not. Only later did he learn that the Range Riders had saddled up the moment they heard that one of their own had bitten the dust.

Bystanders motioned the sheriff to the back bedroom of the spacious cabin that rented for eight dollars and fifty cents a night, not a bargain by post–World War II standards. The clerk had not exaggerated. There was blood, and plenty of it, on the carpeted floor, the walls and especially the bed, where a nude male form lay motionless under a blood-soaked sheet that used to be white.

Gaither barked at the "Range Riders" and the rest of the trespassers, who were wandering around the room leaving their fingerprints on everything

Tex Thornton preparing to drop one of his custom-made "bombs." *Southern Methodist University, Central University Libraries, DeGolyer Library.*

within reach, to stand back. Reaching the bed, he slowly pulled back the sheet and shuddered at the sight. The middle-aged man had been savagely beaten and strangled with a shirt still tightly twisted around his grotesquely swollen neck. Despite all that, the sheriff had no difficulty in recognizing his

bruised and battered features. He was Tex Thornton, the famous oil well firefighter and the best-known resident of Amarillo.

Contrary to his nickname, which gave the impression he was a native of the Lone Star State, Ward A. Thornton was born in Mississippi in 1891. At twenty-two, he took a job with a Cleveland, Ohio company that manufactured torpedoes and learned at an early age the hazardous trade of handling high explosives. Following the end of World War I, he applied his hard-to-come-by skill to extinguishing well fires in the oilfields of New Mexico and Electra west of Wichita Falls.

With his services increasingly in demand in the Texas Panhandle, Thornton made Amarillo his home and base of operations in the early 1920s. Going into business for himself, he built a factory in a canyon a safe distance from town and made the nitroglycerine bombs that became his trademark. Soon, he was widely known and admired as the daredevil who dropped his nitro shells down blazing oil wells and sometimes caught them with his bare hands when natural gas pressure blew the canisters back to the surface.

For the risks he took, Thornton was well rewarded, often naming his own price. By the late 1940s, he was rolling in money, as anyone could plainly see by the diamond rings on his fingers and the wad of bills he always carried.

With the chief of police out of town, the biggest murder case to hit Amarillo in many moons fell in the new sheriff's lap. Paul Gaither knew from the opening bell that it would not be easy.

The motel clerk and the porter, who showed the trio to their cabin, both recognized Thornton but could supply only general descriptions of his two traveling companions. One was an attractive young woman in her early twenties, who paid for the room and signed the register "E.O. Johnson, Detroit, Mich." The other was a thin man a few years older and an inch or two shorter, who said very little and never took off his cap. On another fact the motel employees were in complete agreement: all three guests had been drinking, and Thornton was definitely drunk.

The porter was the last to see the couple. At about ten o'clock, an hour and half after they checked in, he helped them push-start Thornton's late-model Chrysler sedan. He watched the car disappear into the darkness going east on Route 66.

A thorough search of the contaminated crime scene by Sheriff Gaither and his deputies yielded but a single clue of any importance. Next to the bed, they found a pair of pants smeared with blood and "R.L. Leach" written on the inside waistband. In the weeks ahead, every man in a radius

of a hundred miles or more with Leach for a surname would be hauled in for questioning only to be turned loose.

Funeral services were held for Tex Thornton three days after the unknown killer or killers bashed in his head, driving bone fragments into his brain. Any hope the sheriff may have had of the local papers going easy on him in the preliminary stage of his investigation was dashed that afternoon by a front-page editorial in the *Daily News*:

> *The people of Amarillo and the Panhandle are indignant and demanding, and rightly so. In the drug stores, over dry goods counters, across backyard fences, between cups of coffee, a great murmur of protest is rising over the brutal slaying of one of our good citizens, Tex Thornton.*
>
> *From all apparent facts, Tex Thornton gave some hitchhikers a ride (a typical thing for good-hearted Tex Thornton), and they contrived to beat him to death for his money and automobile. This sort of thing cannot be tolerated.*

The combined efforts of law enforcement agencies in Amarillo, the Texas Panhandle, New Mexico and points east on Route 66 pieced together a timeline for Thornton's last day on earth. He had indeed picked up a pair of hitchhikers near Tucumcari, and the three stopped for several rounds of drinks at a bar in San Jon near the Texas line. An hour west of Amarillo, they stopped again, this time to fill up the Chrysler's empty tank. The teenage attendant who pumped the gas positively identified Thornton and confirmed the presence of his two passengers. No one remembered seeing them again until they pulled into the tourist court in Amarillo.

After the mess they made of the crime scene, not much was expected from the Will Rogers Range Riders when they left town headed east on Route 66 to pick up the suspects' trail. But to their credit, the volunteers located the stations in Elk City and Oklahoma City, Oklahoma, where the fugitives bought gas. The trail abruptly ended in Dodge City, Kansas, where the Chrysler turned up abandoned with Tex Thornton's nickel-plated .45 automatic still inside.

In spite of a nationwide alert and extensive press coverage throughout the country, the manhunt gradually ground to a halt. As the months dragged by without so much as a hint of a fresh lead, Sheriff Gaither, along with every man, woman and child in Amarillo, began to doubt whether the killers would ever be brought to justice.

Then, out of the blue in February 1950 came the break that cracked the case wide open. For the second time in as many months, eighteen-year-

old Diana Heaney Johnson handed park police in Washington, D.C. a gift-wrapped confession. Her first attempt at clearing her conscience in January had gotten her committed to a psychiatric ward. The capital cops were convinced that the teen was just another crackpot with a loose screw. But when Johnson showed up again with the same story about a bloody murder in a Texas motel, one park policeman sat up and took notice.

An exchange of telegrams with the Amarillo authorities made it crystal clear to park police that they had a most-wanted suspect in custody. While she waited for Sheriff Gaither to come and fetch her, Diana talked nonstop about the Thornton killing, which she blamed on her husband, Evald. But her version of events, as well as her personal biography, changed with every telling, leading an exasperated East Coast interrogator to declare Diana Johnson "one famous liar."

Even though she had not seen her estranged spouse since running out on him months earlier in Florida, Diana knew where police could lay their hands on him. They followed her directions to a tiny town in northern Michigan on the American side of Lake Superior and captured Evald Johnson without a struggle.

Tipped off to the late-night arrest, the city editor of the *Amarillo Times* dragged a cub reporter out of a warm and cozy tavern and put him on the first plane to Chicago. For his connecting flight to Munising, Michigan, the twenty-two-year-old newspaperman risked life and limb on a small aircraft "with skis on it." But he reached his destination in one piece and took a taxi through the snow-covered streets to the sheriff's office.

The shivering reporter was surprised to learn that he had beaten not only the competition but also Sheriff Gaither to Evald Johnson. He politely asked to see the prize suspect, and an obliging deputy brought him right out.

Johnson was itching to tell his side of the story after hearing the number his wife had done on him. He started at the beginning, explaining that he had flown seventy-two bombing missions in the war and reenlisted in the army rather than return to civilian life. He was stationed in California when Diana Heaney, a runaway all of fifteen at the time, caught his eye. Johnson fell so hard for the promiscuous teenager that he went AWOL over and over again to keep her away from other men until the army had finally had enough and kicked him out.

Not long after his discharge, Johnson tied the knot with his child bride in Utah, where it was perfectly legal for a girl her age to marry. For the next two years, the newlyweds stayed on the move until that fateful day in the New Mexico desert when they caught a ride with Tex Thornton.

When Johnson got to the part about the fatal beating, he did not deny responsibility for the crime. But he wanted the newspaperman, and later the jury, to understand how and why it happened:

> *I saw my old lady walking to the bathroom as naked as the day she was born. The next thing I knew, I was beating him with the butt of the gun. I don't remember anything else. I* [do] *remember holding the gun in the air and saw blood* [on] *my pants.* [He bought the secondhand pants at a Salvation Army store, which resulted in the wild goose chase for a nonexistent suspect named Leach.] *I don't know whether I choked him with the shirt before or after I hit him. I had laid down on the bed in the front room to drink some beer. I must have passed out. But I woke up and saw her naked.*

Johnson paused to ponder his final comment on the subject. "I am ready to let them have what they want to make up for it, even my life."

As so often happens, however, the confessed killer changed his mind after a long talk with the lawyer who stepped forward to take his case. Ernest "Dusty" Miller had tried scores of death penalty cases and never lost a client to the electric chair. Upon hearing Miller's impressive résumé, Johnson let the judge know that he was changing his plea to "not guilty."

To give the state a fighting chance against the likes of the popular and proficient Dusty Miller, Tex Thornton's widow and grown son hired George McCarthy with their own money. The judge and district attorney agreed to his appointment as special prosecutor, and the stage was set for an epic knock-down, drag-out courtroom battle.

In the meantime, Mr. and Mrs. Johnson had been indicted for murder and reunited in the Potter County jail, though not in the same cell. Special Prosecutor McCarthy ended the pretrial suspense by announcing that he would go after Evald first and demand the death penalty.

The murder trial of Evald Johnson began with the obligatory selection of a jury. It did not take long for the sparks to start flying and for the judge to realize that, like it or not, he had been cast in the role of referee. Miller for the defense had no sooner opened his mouth than McCarthy for the state interrupted him with an objection. "I don't want some outlaw lawyer to tell me what's proper!" roared the crafty "country" lawyer. The judge cautioned both barristers to behave themselves, a warning he would have to repeat again and again throughout the stormy proceedings.

To help prospective jurors grasp the legal meaning of "justifiable homicide," the cornerstone of the defense he planned to present on his

client's behalf, Dusty Miller read aloud from a copy of the Texas Penal Code: "Homicide is justifiable when committed by the husband upon one taken in the act of adultery with the wife, provided the killing take place before the parties to the act have separated"—or, in laymen's terms—vacated the premises.

With the law on his side and the finest defense attorney in the Texas Panhandle fighting for him, all Evald Johnson had to do was keep it together on the witness stand. He passed the first test with flying colors by making a good impression with a fresh haircut, a clean shave and a blue double-breasted suit right off the rack. Second, he remembered to stay calm and maintain eye contact with the twelve stone faces in the jury box. Third, he told his story in such a way that the jurors felt sorrier for him than the victim, whose reputation took as bad a beating in court as he had in the motel room. And fourth, he did not allow the aggressive special prosecutor to get under his skin.

Displaying unforeseen stamina and self-control, the well-coached defendant withstood a four-hour cross-examination without once contradicting his prior statements or sworn testimony. At the end of the ordeal, it was Johnson who looked calm, cool and collected and the special prosecutor who was the picture of frustration and failure. To top it all off, the dozen men "good and true" took these final words from Evald Johnson into their private deliberations: "She was my wife. She was not his wife. She was mine."

The jury retired to consider the case at three o'clock in the afternoon on May 16, 1950. It came back with a unanimous verdict of "not guilty" in three hours and nineteen minutes; members were home in time for a late dinner. No one who attended the trial or paid close attention to the newspaper coverage should have been surprised by the acquittal. Outraged, perhaps, but not surprised.

Evald Johnson wound up doing a short stretch in prison for stealing his victim's Chrysler, while Diana, who never stood trial for the murder, received a probated sentence for the same offense. The two went their separate ways and managed to stay out of serious trouble for the rest of their lives.

As for Tex Thornton, he was all but forgotten and eventually replaced by a new "king" of the oilfield firefighters, Red Adair. Today, Thornton's name rarely comes up in conversation or in print, due in no small part to what an online columnist recently called his "ignoble end."

Piney Woods Murder Trial
Texas' Longest

Hunter Bergman sat in his pickup truck on the main street of Corrigan, a small community of 1,400 in the Piney Woods of East Texas, waiting for Dudley Veal to come out of the bank. It was ten days before Christmas 1951, but the fifty-five-year-old oil distributor had not driven to town to ask his former brother-in-law what he wanted to find under the tree on the morning of the twenty-fifth. Bergman had bought Veal's present already and was ready to give it to him right then and there.

Dudley Veal emerged from the bank and started across the street. He did not notice his ex-wife's brother step out of his truck with a 32-40 lever-action rifle and ever so quietly come up behind him. When he heard someone call out his name and turned around to see who it was, Bergman was standing only ten feet away. The stalker fired once from the hip, and the bullet went straight through the defenseless man's arm and deep into his chest. Dudley Veal, forty-three, was dead before he hit the pavement.

Hunter Bergman paused for a moment to admire his handiwork before calmly walking back across the street to Essie's Café, where he figured he could find somebody wearing a uniform and a badge drinking coffee. Bergman made his way to Byrd Purvis's table and, without saying a word, handed the murder weapon to the dumbfounded deputy sheriff. When the lawman showed no interest in putting him under arrest, the killer climbed back in his pickup and drove the twenty-two miles to Livingston, the Polk County seat, where he surrendered to authorities.

The first thing Bergman did after posting bail was to place a long-distance telephone call to the Dallas branch of the family tree. Douglas E. Bergman was a first cousin and a former fire-breathing prosecutor for "Big D" District Attorney Will Wilson, who would leave his indelible mark on Texas history as the state attorney general who shut down the gambling casinos, brothels and other sources of illicit pleasure on Galveston Island. Since cousin Doug was no longer a member of the Texas House of Representatives, thanks to a change of heart by the voters, Hunter thought that he might be free to keep a kinsman out of the slammer.

The politician jumped at the chance to score points with his relatives and to reap the benefits of what was bound to be a highly publicized murder trial. He told his country cousin not to worry and promised him a crackerjack crew of criminal lawyers that would tear the local yokels to shreds.

Douglas Bergman was not kidding. In record time, he recruited four of the finest defense attorneys in the eastern half of the Lone Star State, including none other than Zemmie Foreman, brother of the famous Percy. As soon as District Attorney J.W. Simpson found out what he was going up against, he brought in reinforcements. Two big-city lawyers from Lufkin accepted his invitation to serve as special prosecutors, and the stage was set for the most dramatic courtroom confrontation Polk County had ever seen.

A sacred rule of small-town life is that the inhabitants would rather cut off an arm than air their dirty laundry in front of "outsiders." For the residents of Corrigan, it was bad enough that the trial of Hunter Bergman had to be held in the courthouse in Livingston and would, by law and tradition, be open to the public. But what would make the event utterly unbearable for people who so zealously guarded their privacy were the newspaper snoops from Houston and Dallas and, as they learned at the last minute, the staff writer and photographer sent by *Life* to turn the trial into a feature spread in the largest circulation magazine in country.

On January 29, 1952, forty-five days after Dudley Veal perished on the main street of Corrigan, the sensational murder trial, with its cast of colorful and contentious characters, began in Livingston, seventy-five miles north of Houston. The Bergmans and the Veals, two prominent pioneer families, sat stone-faced on opposite sides of the courtroom, without exchanging so much as a sideways glance. The rest of the four hundred seats were occupied by dignified matrons in their Sunday best, who brought their lunches in paper bags to avoid losing their places during the noon recess.

The selection of the jury took an unprecedented nine days. In the sparsely settled county of sixteen thousand, it was a challenge to find qualified

candidates not on speaking terms with the accused or the victim and who had not formed hard-and-fast opinions regarding the guilt or innocence of the defendant. When the twelfth juror finally took his seat, only twenty members of the original 160-man jury pool remained.

Half of the jury had something in common. Six worked for the same oil company under the same supervisor. Although several made the cut by insisting they were not acquainted with their fellow employees, skeptics wondered how much truth there was in those disclaimers.

Zemmie Foreman made it clear from the outset that he would not dispute the most incriminating fact. There was no denying that his client took Dudley Veal's life, but the attorney claimed that Hunter Bergman committed the crime in self-defense. And taking a page out of brother Percy's playbook, Foreman intended to show that the dead man had it coming.

The prosecution opened with its star witness: high school student Gwendlyn Hudson, who watched the whole thing through the picture window of the furniture store where she worked part time. The teenager testified that she waved to Veal as he exited the bank next door. Then Hudson saw the defendant walking across the street carrying a rifle. "He was raising his gun," she recounted for the jury and the packed courtroom. "Mr. Veal turned and started back. Just as he did, Mr. Bergman fired."

The schoolgirl continued the narration, describing how the mortally wounded Veal collapsed on the sidewalk in front of the furniture store and was dragged inside by her manager. Five minutes later, the local mortician pronounced him dead.

Responding to questions from the district attorney, Hudson said with absolute certainty that Veal had made no threatening move whatsoever toward his attacker. She added that the only weapon found on his body was a pocketknife with a four-inch blade. Not wanting to spend any more time on the open-and-shut case, the prosecution rested before the midday meal after calling just six witnesses.

The defense countered with Elna Veal, Hunter Bergman's forty-four-year-old "baby sister," who told a long and tearful tale of marital woe. She swore that her abusive ex-husband had threatened her life and the life of her protective big brother "many times in the last fifteen years."

A second former brother-in-law repeated from the witness stand another alleged death threat. During a visit to the Veal home the year before the murder, he testified that Dudley, while sitting in a chair toying with a pistol, had announced, "I'm going to kill that (expletive deleted) Hunter Bergman!"

The jury heard from the defendant himself, who contended under oath that he fired the fatal shot because he believed that Veal was reaching for a gun. He blamed his itchy trigger finger on a botched bushwhacking the previous day by his estranged in-law but provided only a photo of a bullet hole in his pickup as proof of the alleged ambush.

On rebuttal, the state countered with a surprise witness, who put Veal someplace else when he had supposedly tried to waylay his avowed enemy. Prosecutors felt that the statement effectively discredited Bergman's ambush claim.

The most dramatic moment of the twenty-nine-day trial, longest in Texas history up until that time, came when Dudley Veal Jr. contradicted his mother on every important point of her testimony. Elna Veal's grown son, who had taken over the family business, said that he never once saw his father physically abuse her, nor did he ever hear him threaten anyone with bodily harm.

His uncle's lawyers realized that they could not let Dudley Jr.'s statements stand. They subjected the young man to a blistering cross-examination that climaxed with Douglas Bergman shouting, "You got up on that stand and branded your mother a liar! She who gave birth to you and your sister! You should have more respect for her!"

The politician presented the opening summation for the defense and showed that he had missed his true calling. His wild gestures and over-the-top oratory, which included dropping to his knees and appealing for divine intervention, would have done any fire-and-brimstone evangelist proud. Cousin Douglas concluded with a plaintive plea for "the right of this defendant to sit down with his good wife and little boy and [to] play dominoes with his friends."

Four hours into the six set aside by the judge for closing arguments, Zemmie Foreman pulled a fast one. He approached the jury box and said in the most sympathetic tone he could muster, "Gentlemen, I know you're tired. If as many as six of you hold up your hands indicating you've heard enough argument, and the state will agree, I'll sit down." Eleven arms instantly shot up. The twelfth juror either did not hear the question, a possibility considering his age, or he truly wanted to hear more.

Foreman gave the stunned district attorney a satisfied "gotcha" grin and sat down to watch him squirm. If ever a prosecutor found himself caught between a rock and a hard place, it was J.W. Simpson on that afternoon in February 1952. He could demand his right to have the last word and risk alienating the jury, or he could let Zemmie Foreman have his way and hope he had made his case for coldblooded murder.

After a brief huddle with his co-counsels, District Attorney Simpson grudgingly announced that the state would abide by the results of the unorthodox show of hands. Minutes later, the jurors had their final instructions from the judge and all the time in the world to decide Hunter Bergman's fate.

After the record-setting length of the trial and testimony from no fewer than eighty-four witnesses, no one expected to see the dozen jurors anytime soon. But they came back in an hour and a half with a verdict.

"Not guilty!" bellowed the bailiff, whose nickname was "Dynamite."

One side of the courtroom celebrated, while the other wept. An elderly spectator gave a newspaper reporter her two cents worth. "Well," she solemnly observed through pursed lips, "it will take a full generation and more of Bergmans and Veals to heal this breach!"

Billie Sol Estes and the Five-Shot Suicide

In his heyday, Billie Sol Estes—with his coal-black hair, matching glasses and plump physique—looked like the Pillsbury Doughboy in a bad disguise. Behind that amusing appearance was a world-class swindler willing to do anything and take advantage of anybody to make a buck. A baffling blend of strait-laced morality and cutthroat cunning enabled the pudgy promoter from Far West Texas to make his first million before he was thirty, but ambitious Billie Sol was just getting started.

Even as a boy growing up on the dusty outskirts of Abilene, he showed a precocious talent for turning a profit. Beginning with a single ewe given to him by his dirt-poor parents, he wound up a decade later with a $38,000 nest egg.

Settling at Pecos in 1950, Billie Sol earned an honest living raising cotton, but this modest success did not put a dent in his burning ambition. Taking advantage of the high-profit loopholes in the national farm subsidy program, he built an illicit empire worth an estimated $150 million.

In the beginning, Billie Sol was nothing worse than a shrewd businessman playing the angles. He borrowed to the hilt in order to put more land in cotton and then turned around and sold his crop at government-supported prices. The same strategy in the grain storage game yielded spectacular windfalls, which he then invested in a new project: anhydrous ammonia fertilizer.

Persuading obliging farmers to sign mortgages for a fleet of fertilizer tanks, Billie Sol cleverly leased the tanks back to himself and peddled the mortgages to banks scattered around the country. In time, however, he got

carried away and crossed the line into criminal fraud by selling phony titles to phantom tanks that existed only on paper.

Worried bankers knew that Billie Sol was headed for trouble. Their reluctance to blow the whistle on the wheeler-dealer proved the Estes adage that creditors always have a stake in the survival of a big debtor. As he once put it, "If you get into anybody far enough, you've got yourself a partner."

In the shadow of his impending doom, Billie Sol lived high on the hog. He built a sprawling, pink-stucco home in Pecos and installed a waterfall in the living room. While his neighbors' lawns wilted in the searing summer heat, expensive dye kept the Estes yard green year-round. Anybody Billie Sol wanted to impress was presented with a pair of $150 alligator shoes. So long as the money was rolling in, no extravagance was too extreme.

Offering his services to the people of Pecos, Billie Sol ran for the school board on a prudish platform that called for banning dances and creating segregated drinking fountains for the sexes. To his embarrassed surprise, the voters turned him down flat.

Snubbed at the polls, he wiggled into politics through the back door as a high-rolling contributor. In November 1960, he organized a huge benefit barbecue for U.S. Senator Ralph Yarborough, an event that would come back to haunt the guest of honor in more ways than one. It was at this fundraiser that the senator allegedly accepted $50,000 in cold cash from his generous host, an accusation that followed Yarborough like a dark cloud for the rest of his career and into retirement.

By the summer of 1961, government investigators from Texas to Washington, D.C., were zeroing in on Billie Sol Estes. One of those sleuths was Henry Marshall of the U.S. Department of Agriculture, whose past dealings with the politically connected con man had caused him to suspect fraud on a mind-boggling scale.

On June 3, 1961, Marshall drove from his home in Bryan to his 1,500-acre ranch north of Franklin, the seat of Robertson County, by way of his brother-in-law's place. There he left his young son for the day with L.C. Owen. The boy got a kick out of riding shotgun with his uncle while the soft drink deliveryman made his rounds.

Sybil Marshall could always set her clock by her husband, who made a habit of being on time. When Henry had not shown up at home at five o'clock, an hour later than he told her to expect him, the concerned wife called her brother and implored him to drive out to the ranch. Owen did as she asked, not believing for a second that anything was wrong. Once at the cattle spread, he took a look around, saw no sign of Marshall or his pickup

and went straight home. The telephone was ringing off the hook when he walked in the door. It was Sybil again, and she was beside herself with worry over the whereabouts of her usually reliable spouse.

On his second trip to the ranch, L.C. Owen took along a second pair of eyes. A systematic search ended with the discovery of Henry Marshall's dead body in a pasture near his pickup. Leaving his companion to stand watch, Owen made a beeline for Franklin to notify the chief county cop. Sheriff Howard Stegall, in turn, called Lee Farmer, the aged justice of the peace, to let him know that "a man had killed himself." Owen later swore that the lawman jumped to that conclusion without any prompting from him.

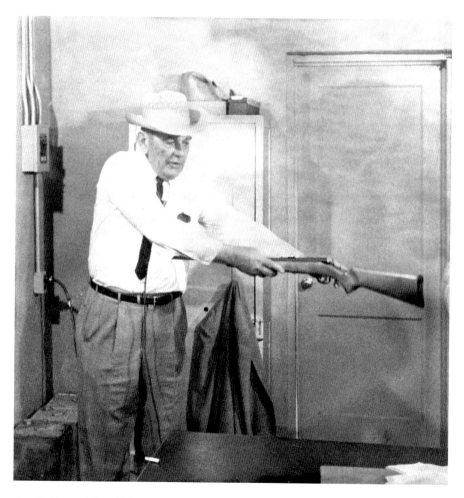

Sheriff Howard Stegall demonstrates his theory of "five-shot suicide" with Marshall's rifle. *RGD0005f7255, Houston Public Library HMRC.*

The sun was going down by the time Sheriff Stegall and Deputy Sonny Elliott reached the ranch and followed L.C. Owen's directions to the body. Henry Marshall was flat his back with five bullet wounds in the left side of his chest and upper abdomen. Close by but beyond the dead man's reach was the bolt-action, .22-caliber rifle that the sheriff presumed Marshall had turned on himself *five* times. Already fixated on suicide as the cause of death, Stegall placed no importance on the absence of bullet holes and blood on the front of Marshall's shirt, the gash on the side of his head or the scratches on his hands.

The pickup was parked a short distance away, but just how far no one could ever say for sure since the sheriff did not bother to take any measurements. He also decided that it was not worth the time and trouble to collect blood samples from the smears on both doors, the hood and the right rear panel. Evidence that did not fit his rush-to-judgment was ignored or discounted as irrelevant.

Stegall attached much more significance to the way Marshall's personal effects were displayed on the seat inside the truck. Only a man making ready to end his life would have removed his glasses, wristwatch and the pencils from his shirt pocket. Marshall's meticulous preparations apparently failed to include a final farewell to his loved ones because he did not leave a suicide note.

On the long list of standard investigative procedures the sheriff ignored was to have the rifle checked for fingerprints on the off chance he had it all wrong. Since he was never wrong, why bother?

The justice of the peace did not make it out to the pasture until the next day. A briefing from Sheriff Stegall and a chat with L.C. Owen were enough to convince Lee Farmer that it was a clear-cut case of suicide. The JP released the pickup to the brother-in-law, who had it washed that very day, removing the blood smears and all other physical evidence.

The first to express serious doubts about the suicide ruling were Henry Marshall's next of kin and close acquaintances. While he sometimes showed signs of job-related stress, he never had exhibited the slightest symptom of depression. As someone who knew him for a long time later told the Texas Rangers, "Marshall had a wife, a young son, land, cattle and money in the bank. He had no reason to take his life."

Marshall's friends and relatives were not the only ones to question the suicide theory. The mortician at the Bryan funeral home, who prepared the body for burial, had never seen a suicide with a head injury and hand abrasions like Marshall's. He told Lee Farmer so in a telephone conversation

that escalated into an argument, but the justice of the peace dug in his heels and flatly refused to reconsider his ruling.

And that was that for the next eleven months. In the meantime, Billie Sol Estes's bubble finally burst due in part to a Pulitzer Prize–winning exposé by the editor of the *Pecos Independent*. The formerly untouchable wheeler-dealer was indicted and awaiting trial on federal fraud and conspiracy charges when the secretary of agriculture dropped a bombshell that rattled windows across the country.

Orville Freeman stunned reporters at a press conference in May 1962 with the revelation that Henry Marshall had been delving into Billie Sol's nefarious activities at the time of his death. Suddenly, the forgotten story of the five-shot suicide was front-page news and the talk of Washington.

At the behest of his brother, President John F. Kennedy, Attorney General Robert F. Kennedy asked the Federal Bureau of Investigation to get to the bottom of the Marshall case. Director J. Edgar Hoover, who hated the Kennedys with a passion and as a rule paid no attention to their requests, played ball for once. He, too, wondered what was going on down in Robertson County. On a report about the haphazard investigation into the death of the Texan on the federal payroll, Hoover wrote, "I just can't understand how one can fire five shots at himself."

The same question confounded Colonel Homer Garrison, the director of the Department of Public Safety (DPS), who gave the Texas Rangers their marching orders. He could not stop the FBI from snooping around, but he could do everything in his power to crack the case before Hoover's agents.

Garrison knew just the man for the job: Ranger captain Clint Peoples. The most respected state lawman of his day, Peoples grabbed hold of the Marshall mystery and refused to let go. He spent weeks in Robertson County scouring the ranch for the smallest clues, interviewing every individual remotely connected with the case and verifying their statements with a lie detector.

The mounting publicity and political pressure compelled officials to take a second look at how Henry Marshall died. A grand jury was hurriedly convened, and hoping that an outsider might remove the monkey from their backs, a big-city coroner was brought in to conduct an autopsy of the exhumed remains.

Dr. Joseph Jachimczyx had been the chief medical examiner of Harris County for less than two years, but his inexperience did not cause him to think twice about accepting the assignment. This was his chance to step into the national limelight, and he was not about to pass up the opportunity even if he was in way over his head.

Dr. Joseph Jachimczyx, Harris County medical examiner, could not decide how Henry Marshall died. *RGD0005f487, Houston Public Library HMRC.*

Despite his training, Jachimczyx did not see himself as an independent scientist duty-bound to let the forensic chips fall where they may. Throughout his thirty-five-year career, he was the best friend Houston prosecutors and police ever had. They would tell him what they needed to prove their case, and "Dr. Joe," as he was affectionately called by the

DA's office and local news media, would find a medically plausible way to make it happen.

The dilemma Jachimczyx faced in his 1962 autopsy of Henry Marshall was that he had no clear idea who he was supposed to make happy. So, he wound up splitting the difference. Jachimczyx's original opinion, which he voiced at a press conference following the eight-hour postmortem, was plainly pro-murder. "Based on my preliminary examination," he said to a sea of print reporters and television cameras, "I believe that this was not a suicide."

However, in his written report issued a few days later, Jachimczyx hedged his bet. "Being familiar with bizarre gunshot wounds one cannot say…on a purely scientific basis that a verdict of suicide is absolutely impossible in this case. Most improbable but not impossible."

Ranger captain Peoples could not have disagreed more with the coroner's wishy-washy position. In his testimony to the grand jury, he came down firmly on the side of murder. His theory of the crime was this: Henry Marshall was attacked in the pasture by one or more parties and sustained a wound to his head in the ensuing struggle. After he fought off an improvised attempt to asphyxiate him with carbon monoxide from the pickup exhaust, the killers shot Marshall with his own rifle and did their best to make it look like a suicide.

For Sheriff Stegall, a subject of scorn and ridicule in the months since his controversial call, Dr. Jachimczyx's second opinion amounted to nothing less than full vindication. The justice of the peace was positively elated. "When I come to the Pearly Gates, if St. Peter asks me about Henry Marshall, I'll still say it was suicide. Nobody told me to write it that way, and nobody bribed me either."

Those grand jurors who leaned toward changing the cause of death to homicide were undermined by the Houston medical examiner's muddled effort to satisfy both sides. Without an unequivocal ruling of murder from Jachimczyx, the grand jurors felt that their hands were tied. Ten of the twelve voted to let the original death certificate stand, and the panel disbanded.

As for Jachimczyx, he simply could not leave well (or, in this instance, bad) enough alone. Three months after the autopsy, he once more spoke out of both sides of his mouth in a letter to the grand jury judge. "If, in fact, this is a suicide, it is the most unusual one I have seen during the examination of approximately fifteen thousand persons." He closed with this "go get 'em" statement: "I agree wholeheartedly that the investigation in this case should be continued as a Murder Case."

After that final piece of advice, Dr. Jachimczyx kept his distance from the Marshall case and wisely stayed closer to home. But his misreading of two related crime scenes in the 1970s nearly let a contract killer and his employer get away with four murders.

In 1975, Gertrude Zabolio was strangled with a pair of pantyhose in a bathroom of her River Oaks mansion in the swankiest part of town. To the untrained eye, it looked like murder, but not to Dr. Joe, who determined that the sixty-year-old socialite accidently suffocated while having kinky solitary sex.

Four years later, Zabolio's daughter shot her baby and husband to death before putting a bullet in her own head, according to Dr. Jachimczyx. But a dedicated homicide detective knew a triple murder when he saw it and refused to abide by Dr. Joe's ruling.

Johnny Bonds jeopardized his career and his marriage but ultimately proved the medical examiner wrong. It was no coincidence that the two women were mother and daughter or that their adopted son and brother profited from their passing. Markum Duff-Smith and his hit man, Allen Janecka, were convicted of the killings and put to death in 1993 and 2003.

Any other coroner in any other major metropolis would have been out of a job after blowing such a big case, but not Dr. Jachimczyx. Calls for his firing fell on deaf ears, and he did not hang up his white coat until his retirement in 1995.

When the feds came for him at his palatial Pecos home in the winter of 1962, Billie Sol Estes had no comment concerning the charges brought against him. But he would have plenty to say about Senator Ralph Yarborough after the politician, when told that his former benefactor was in jail, innocently asked, "Billie Sol who?"

Convicted in 1963 on mail fraud and conspiracy in connection with his fertilizer tank scam, Billie Sol was slapped with a fifteen-year prison term. Paroled in 1971 after six years and four months, he was freed on the condition that he work for his brother as an ordinary farm hand and shun "any promotional activity."

The Justice Department may have been finished with Billie Sol, but a second federal agency was just warming up. The Internal Revenue Service put the washed-up wheeler-dealer through the wringer before taking him to trial in 1979 for tax evasion and concealment of assets. Again found guilty, the two-time loser returned to La Tuna, the low-security federal correctional institution outside El Paso, for an additional four years.

The death certificate for Henry Marshall showed the cause of death as "gun shot wounds self inflicted." *RGD0005f7255, Houston Public Library HMRC.*

Who could have guessed that the person who broke the logjam on the disputed circumstances of Henry Marshall's demise would be none other than Billie Sol Estes? In exchange for an ironclad guarantee of immunity, the ex-convict agreed to answer any and all questions from a new grand jury in Robertson County.

Estes made his historic appearance in March 1984 and talked a blue streak for four and a half hours. He laid the blame for the Marshall tragedy on the grave of an ex-president, claiming that Lyndon Johnson had personally given the order. This accusation, as sensational as it was uncorroborated, generated the publicity the witness wanted for an upcoming book tour.

The grand jurors did not necessarily believe a word that came out of the world-class liar's mouth, but they seized the opportunity to set the record straight after a quarter of a century. The cause of death was officially changed to "murder."

Thirty years later, there has been no arrest, no indictment and no trial. Odds are that the killer or killers are six feet under by now, as are the string-pullers who condemned Henry Marshall to death. But who can say? Someday the truth just may come out.

Miami Murder Mystery Made in Texas

For seven riveting weeks in the winter of 1966, a made-in-Texas murder trial in Miami, Florida, kept Americans in every corner of the country on the edge of their seats. The courtroom spectacle that the national news media hyped as "the trial of the century" had every guilty pleasure under the sun: a victim with a bashed-in skull and three dozen stab wounds, a platinum-blond widow accused of conspiring with her nephew/lover to kill her multimillionaire husband and a multitude of titillating sins, ranging from adultery and incest to homosexual sex parties.

The question on everybody's lips was this: Would a larger-than-life Texas lawyer get Candy Mossler and Mel Powers off?

Candy always claimed that her Georgia birth certificate had it wrong. Yes, she was born Candace Grace Weatherby on February 18, but in 1927, not in 1920. That would have made her twelve years old instead of nineteen when kinfolk pressured her into dropping out of school and marrying a much older man in 1939.

The sixth of twelve children in a rural farm family, Candy had a hard life from the start. Her mother died in childbirth when she was only eight, and soon after this tragedy, her father left for parts unknown. Candy's grandfathers, one a banker and the other a Mormon bishop, stepped in and shared responsibility for her upbringing.

As if losing both parents at such an early age was not bad enough, Candy came down with polio the following year. She awoke from a lengthy coma to the heartbreaking realization that she was paralyzed from the waist down.

Candy Mossler, with her adopted sons at her side, charms reporters at the Houston airport. *RGD0006n-1965-2659fi.13, Houston Public Library HMRC.*

For a little girl with dreams of becoming a dancer, the crippling condition was almost too much to bear.

However, with the encouragement of her grandfathers and many other relatives, she found the strength to fight the disease that destroyed so many young lives. Her brothers, for example, took turns carrying her to school on their backs. After five long and painful years, she regained the ability to walk with a scarcely noticeable limp, and soon after that, she put on her dancing shoes.

By 1948, Candy Weatherby Johnson was divorced from her first husband and living with her two children in New Orleans. It was in the Crescent City that the successful model and fashion designer met Jacques Mossler, a fifty-three-year-old Rumanian refugee who had made a fortune in auto sales, financing and commercial banking. Six months later, they married and moved into the groom's twenty-eight-room mansion in the exclusive River Oaks section of Houston.

Mossler waited until after the honeymoon to tell his bride, who had her heart set on an even bigger family than their combined six children, that he was sterile. Candy made him promise to adopt, and eight years later they took in four siblings between the ages of two and six, the survivors of a crazed father's killing spree in Chicago.

In 1962, the Mosslers welcomed a new houseguest: Melvin Lane Powers. Over the next year, Candy developed a shockingly close and affectionate relationship with the twenty-one-year-old son of one of her sisters. By the summer of 1963, Jacques Mossler had figured out what was going on under his very roof. He kicked Mel Powers out of the house, fired him from his job with a Mossler company and left for Europe on a long vacation to think things over.

During his extended absence, Candy and Mel were the hottest item in Houston. They no longer bothered to hide their scandalous affair, and the young nephew even went so far as to introduce his middle-aged aunt as his fiancée.

It was also around this time that Candy discovered that her husband had gone back on his promise to provide financial security for all the children. Jacques had set up trust funds worth $2.5 million each for his four daughters but had not put aside one red cent for the four adopted kids or Candy's two grown children.

When Mossler returned to the States, he rented an apartment in Key Biscayne, Florida, instead of going home to Candy and the kids. Then, in the early hours of June 30, 1963, someone bashed in his skull and stabbed him thirty-nine times.

Jacques' mutilated body was discovered at 4:30 a.m. by his estranged wife and the four children still living at home, who had come to Florida for a visit. Candy had taken the kids for a ride three hours earlier but was detoured by one of her migraine headaches. At the emergency room where she was a regular customer, she refused the usual injection from a nurse and instead insisted on waiting for a doctor.

Mel Powers, who also happened to be in Key Biscayne that evening, did not have such an airtight alibi. He claimed to have been at the movies in the middle of the night but could not recall what picture was showing. Mel was arrested four days later in Houston and charged with the brutal murder. Candy desperately wanted the best defense attorney for her nephew that money could buy, so she naturally turned to Percy Foreman. The legendary lawyer accepted $50,000 in jewels as the down payment on his $200,000 fee.

A Miami grand jury indicted Mel *and* Candy for first-degree murder in July 1965. Deciding to risk his perfect record as a prosecutor, State's Attorney Richard E. Gerstein announced that he would try the case himself and demand the death penalty.

Since Foreman could not defend both defendants due to a possible conflict of interest, Clyde Woody, a top-notch Houston attorney in his own right,

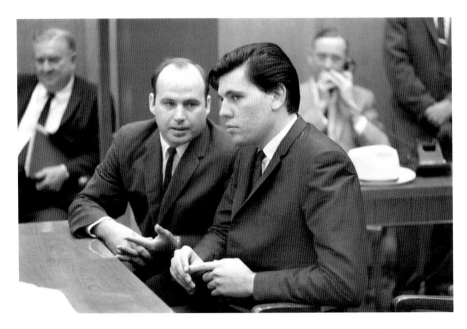

As per Foreman's orders, Melvin Lane Powers (right) did not say a word to the media until the verdict came in. *RGD0006n-1964-6749ft.9A, Houston Public Library HMRC.*

came on board as Candy's lead counsel. But there was never any doubt who was in charge of the defense.

The R-rated trial began on January 17, 1966, and held the whole country spellbound for the next two months. No one under the age of twenty-one was allowed in the courtroom, and a Miami newspaper printed extra editions on hot-pink paper.

Percy Foreman's vast experience, with more than one thousand death penalty cases in his six-decade career, had taught him that picking the jury was half the battle. So, as usual, he took his time—in this instance, two full weeks—and did not mince any words. Since the last thing he wanted was a narrow-minded, holier-than-thou citizen to sit in judgment of his clients, he asked prospective jurors whether they would hold it against Candy and Mel if the evidence showed they were involved in incest, adultery and fornication.

The twelve jurors took their seats, and the eagerly anticipated trial finally got underway on February 1. Foreman listened patiently with an amused look on his face to the opening barrage from the team of prosecutors. Then came his turn to speak, and a hush fell over the jam-packed courtroom:

Distinguished gentlemen of the prosecution, Your Honor, the Court, gentlemen of the jury and alternates. We believe that the evidence in this case suggests that, if each of the thirty-nine wounds inflicted on Jacques Mossler on the early morning of June 30, 1964 had been done by different people—that is, thirty-nine different people—there would still be at least three times that many people in Florida and the Mossler empire with real or imaginary justification to want the death of Jacques Mossler.

In other words, there was a legion of suspects with as good or better reasons to take Mossler's life than the two defendants. Even if Candy and Mel had wanted him dead, they would have had to stand in a very long line.

During a lunch break, a reporter asked Candy, "There have been some terrible charges against you here this morning. Do you have any comment?" She flashed her dazzling smile and said, "Well, sir. Nobody's perfect."

Another journalist tried in vain to persuade Foreman to grant him an interview with Mel Powers, who, as per his attorney's strict orders, had not said a single word to the news media since his arrest. "My boy, all my clients have a right to be stupid," Percy replied with his exaggerated drawl. "Otherwise, they wouldn't get in trouble in the first place. But sometimes they abuse the privilege." That meant, in Foreman "speak," that Powers would continue to keep his mouth shut.

The prosecution pinned its hopes on the testimony of five witnesses, each of whom swore under oath that either Mel or Candy had attempted to hire them to kill Jacques Mossler. The problem was that three were career criminals were zero credibility, and Foreman and Woody made mincemeat of the entire quintet on cross-examination.

Of the five, the most potentially damaging accusations had come from Billy Frank Mulvey, an inmate in the Texas prison system who testified that on more than one occasion Mel Powers had offered him a five-figure payment to kill Jacque Mossler. Upon cross-examination, Foreman tossed a handful of documents in the convict's lap and instructed him to "examine these thirty-four instruments and see if they apply to you." Mulvey flipped through the stack of papers in wide-eyed amazement before exclaiming, "Great God Almighty! Is this all *my* record? You sure dug deep!" Spectators and jurors alike erupted in laughter. Any chance of the jury believing anything Mulvey had to say went right out the window.

Besides a weak lineup of witnesses, the prosecution was handicapped by the lack of a murder weapon. The Dade County medical examiner said on the witness stand that the victim's thirty-nine puncture wounds had been inflicted "probably by a thin-bladed knife four to six inches in length."

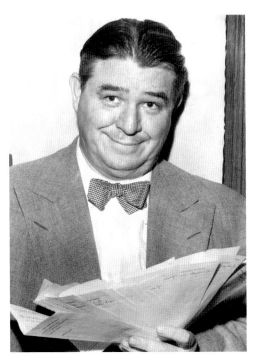

Percy Foreman with the impish grin he used to charm the Miami jury. *RGD0005f2973, Houston Public Library HMRC.*

But investigators failed to find the knife in question and, with it, any telltale fingerprints.

Foreman opened his five-hour closing argument by damning the chief prosecutor with faint praise. "I congratulate Richard Gerstein. It took guts and courage for him to appear personally in this case when he could have given the job to a subordinate. Few prosecutors would have chosen to appear in a case where the evidence is not overwhelming let alone almost absent."

He passed on Jacque Mossler's purported homosexuality, an allegation the state had spent hours attempting to refute, but took the issue of incest head-on by inquiring why the defendants had not been charged with that offense. He recited the relevant statute from a Florida law book and noted with his customary grin that the maximum penalty for incest was twenty years in a state prison or one year in a county jail. "You must have a pretty terrible county jail here, if one year there is as bad as twenty years in the penitentiary!" Once again, the spectator section roared with laughter.

After the judge restored order, Foreman ridiculed the prosecution for basing so much of its case on the rumored sins of his clients. "I am glad we have a moral-minded district attorney and also an assistant district attorney who underwrites that moral-mindedness. I'm sure they will stop fornication and eliminate adultery and assignation [secret lovers' rendezvous]. They're going to stamp it out. I know they are. It's a shame the world has had to wait so long for that crusade."

Foreman paused to let that point sink in before comparing the evidence to "a wheelbarrow of manure dumped from the witness stand." He turned on his heel to face the jury box before adding, "And they ask you to swallow it." The graphic imagery caused several jurors to wince in disgust.

The spellbinder aimed his last blast at the table of shell-shocked prosecutors. "They want you to forget the evidence," he said his voice rising with each word. "Let's guess these people into the electric chair. That's what they want you to do, fellers. Burn 'em, fry 'em, help me kill 'em. The newspapers are waiting for a verdict."

In his instructions, the judge gave the exhausted jury a way out. Instead of finding Candy and/or Mel guilty of capital murder, they could compromise on second-degree murder or even manslaughter. It was the worried jurist's obvious attempt to avoid a hung jury and a mistrial.

The jury was out three days and took six inconclusive votes. At one point, the foreman informed the judge that they were deadlocked with no hope of reaching a unanimous verdict. He refused to let them off the hook and ordered them to resume deliberations.

On Sunday morning, March 6, the dog-tired dozen sent word to the judge that they had agreed on a verdict. Percy Foreman was not present to hear the clerk announce that both defendants had been found "not guilty as charged." His car broke down on the way to the courthouse.

After the reading of the verdict, Mel Powers at last had something to say. It was one word: "Beautiful." Candy Mossler could not stop the tears as she showed her joy and gratitude by kissing every member of the all-male jury.

"That innocent boy" and "that sweet little woman," to quote Percy Foreman from his trial-winning summation, lived together for a while but not happily ever after. Candy and Mel went their separate ways after a couple of years, each with enough of Jacques Mossler's money to last a lifetime.

Candy Mossler divorced her third husband, eighteen years her junior and three years older than Mel, in 1975 and the next year went back to Miami on business. She accidentally overdosed on migraine medication, fell asleep facedown on a pillow and suffocated to death. How old was she? Somewhere between forty-nine and fifty-six.

Melvin Lane Powers outlived his aunt and lover by thirty-four years. Colorful and controversial, he loved to play the big shot as an up-and-down Houston real estate developer. In an ironic twist, he, too, suffocated in his sleep, a victim of what the coroner called postural asphyxia. Mel Powers died in 2010 at sixty-eight.

As for Percy Foreman, to whom Candy and Mel owed their freedom, the reigning king of the courtroom kept on beating murder raps right up until he passed away in 1988 at the age of eighty-six. When it came to saving accused killers from electrocution and lethal injection, the folksy Texan was the best there ever was.

Civil War in River Oaks

The baby girl Ash Robinson and his wife, Rhea, adopted in 1931 was not some stranger's castoff but rather the biological daughter of the wealthy Houston oilman. That particular family skeleton was kept locked away in the closet until Joan Olive Robinson was nearly grown, and that was why she grew up believing that she hit the jackpot the day her parents picked her out at the local foundling hospital.

Since the 1920s, when two sons of a former Texas governor created the inner-city sanctuary, River Oaks was where the rich and powerful lived. New money, mainly from oil, vied with old in the continuous contest to show whom God had blessed the most, monetarily speaking.

As the only child of a doting multimillionaire, Joan Robinson got everything her little heart desired and often before she even thought to ask. Her early interest in horses, triggered by a pony ride at the age of four, resulted in a showcase career as a champion equestrian that earned her national renown and five hundred trophies. The final appearance of her favorite mount, Beloved Belinda, was covered by no less than *Sports Illustrated*.

The talent Joan exhibited with horses failed her when it came to men. She wound up a twice-divorced socialite at twenty, a scandalous achievement even by the fickle standards of River Oaks. Her father had strongly objected to both brief marriages and vowed that he would not permit his princess to end up a three-time loser.

While Ash Robinson was not thrilled with his little girl's third choice, he took comfort in the fact that she had waited six years to make it. And Joan

Socialite Joan Hill and Dr. John Hill were all smiles before their marriage hit the rocks. *RGD0005f6681, Houston Public Library HMRC.*

could have done a lot worse than John Hill, who like his father-in-law had come from humble beginnings. He was working his way through medical school and planned to specialize in plastic surgery.

Eleven years into the marriage, Dr. Hill was "one of the city's leading plastic surgeons," at least in the opinion of the *Houston Chronicle*. But in the husband and father departments, he left a lot to be desired, especially in the eyes of ever-watchful Ash. He paid little attention to his son, Robert, who was stuck with the too-cute nickname "Boot," and even less to Joan.

As a busy surgeon, Hill did not have much time to spare and preferred to spend his off hours with his mistress, Ann Kurth, a mother with three children and the same number of ex-husbands. Joan was completely unaware of his infidelity until his surprise announcement in the fall of 1968 that he wanted a divorce.

Ash Robinson took a position of "good riddance" until his daughter begged Daddy to help save her marriage. So, he summoned his cheating

son-in-law to a private summit at the Robinson mansion and presented Hill with a prepared letter of apology along with a plea for reconciliation. All the no-good doctor had to do was sign on the two dotted lines and go home to his wife. If he was foolish enough to refuse, Ash promised to take him for everything he was worth as compensation for the financial support he had provided the couple during the lean early years of their marriage.

Caught between the proverbial rock and a hard place, Dr. Hill gave in and went back to his wife with his tail between his legs. Ann Kurth, sick and tired of playing the mistress part, laid down the law, telling John that the time had come to choose between the two women in his complicated life. Three months passed without a resolution. Hill was doing a bad impersonation of a repentant husband and father while also doing his best to keep the "other woman" happy.

In early March 1969, two close friends of Joan's came for an extended visit and, at her urging, stayed in the Hills' mansion, also in River Oaks. Diane Settegast and Eunice Woolen would later have a lot to say about the strange goings-on they observed. For example, several nights in succession, John returned with pastries after being called away from home by a message on his pager. Instead of letting the three women pick and choose, he insisted on personally selecting each one's treat.

Joan spent most of Saturday, March 15, in bed. When her worried guests checked on her that afternoon, she waved off their concern with an "under the weather" excuse. Gently pressed for details, she explained, "John gave me some pill last night and it really knocked me out." Joan remained in bed until the women took their leave two days later. The last time Settegast and Woolen saw her on the morning of Monday, March 17, she complained of feeling dehydrated and requested a glass of water.

When Dr. Hill left for work a little while later, he gave Effie Green, the maid on loan from his in-laws, strict instructions not to disturb his wife. The domestic did as he commanded and did not enter the master bedroom until the follow morning. When she did, she found Mrs. Hill lying in her own feces, with bloodstains on towels that had been put underneath her.

Effie Green placed a frantic call to her husband, who also worked for the Hills, and asked him to contact the Robinsons. But Joan's parents were not at home. They were on their way to her house.

Ash deposited his wife on the doorstep and drove on to an appointment. Rhea Robinson had no idea that her daughter was sick as she followed the agitated maid up the staircase. She opened the bedroom door to see her son-in-law standing at the foot of the bed and Joan covered in urine, feces and

vomit. Anticipating the logical question from the horrified Mrs. Robinson, John stated the obvious: it might be a good idea to take Joan to the hospital.

At this critical moment, Dr. Hill made two controversial calls. First, he elected to drive his desperately ill wife to the hospital rather than call an ambulance. Second, even though Houston's already world-famous medical center was a mere fifteen minutes away by car, he picked a new suburban hospital more than twice the distance with no emergency room or intensive care facility.

Soon after admitting his wife to Sharpstown General and giving the nurses a cursory description of her symptoms, John Hill vanished. Doctor after doctor scrambled to save the dying patient without a diagnosis to guide them. When Joan's kidneys started to fail, they contacted Dr. Hill to obtain his consent for a last-resort treatment, which he refused to give over the phone. He said he was leaving right then for the hospital but did not show up for almost two hours.

Instead of staying by Joan's side, like she begged him to do, Hill stretched out on a couch in a storage room and fell sound asleep. An hour and a half later, as her husband slept, Joan Robinson Hill gasped for one last breath and died with blood gushing from her mouth.

The law in Texas in 1969 was crystal clear. For any person pronounced dead within twenty-four hours of admission to a hospital, an autopsy was mandatory. Yet in blatant violation of this statute, Sharpstown General released the body of Joan Hill to a funeral home less than four hours after her passing. When the hospital pathologist caught up with the corpse the next morning, it had been drained of every drop of blood and filled with embalming fluid. He came to no firm conclusion on the cause of death and could only guess that the healthy woman might have died from pancreatitis.

Five months later, Ash Robinson hired the chief medical examiner for New York City to take a second and more thorough look. Dr. Milton Helpern was taken aback by the mess his predecessor had made of the initial postmortem. He had not gotten around to removing the stomach and inspecting the contents—standard procedure—but had taken out the brain and heart and forgotten to put them back before burial. The New Yorker's mortified counterpart remembered leaving the brain in the trunk of his car but could not come up with the missing heart.

Good as he was, Dr. Helpern was handicapped by the lack of blood samples resulting from the hasty embalming. In his final report of April 1970, he cited Dr. Hill's home remedies and slowness in moving his gravely ill wife to a hospital setting as contributing factors in her demise but could

Oilman Ash Robinson, shown with wife Rhea, went to his grave convinced that Dr. John Hill murdered his daughter. *RGD0005f2234, Houston Public Library HMRC.*

not determine "the specific origin" of the "fulminating infection" that caused her death.

Ash Robinson believed with every fiber of his being that John Hill had murdered his beloved daughter and devoted every waking hour and much

of his fortune to making him pay for his crime. Relentless pressure from the grief-stricken father compelled the district attorney to present the case to not one, not two but three grand juries. The third time proved to be the charm as the first-ever indictment for murder "by omission," the intentional withholding of lifesaving medical care, was returned against Dr. Hill.

John, who had married his mistress less than three months after Joan's funeral, was already anxious to cut her loose. His lawyer advised against it, pointing out that Ann could not testify against him as long as they were man and wife, but his know-it-all client would not listen. He divorced Ann on the eve of the April 1970 indictment and, in effect, freed her from the marital vow of silence.

The spurned ex-wife talked her head off at Hill's trial the following February. She claimed under oath that he had confessed to killing Joan with poison he secretly cultivated in petri dishes in his bathroom. Before she vacated the witness stand, Ann accused the defendant of trying to kill her, too, by deliberating ramming their car into a concrete bridge.

The judge had heard more than enough of Ann's unsubstantiated charges and promptly granted a defense motion for a mistrial. The DA preferred a retrial to Ash Robinson's wrath, and the second round in the courtroom drama was put on the calendar for November 1972.

During the break between trials, Hill tied the matrimonial knot for the third time. On the night of September 24, 1972, he returned home with his new bride, Connie, to find a paid assassin waiting in the foyer of his mansion. Connie broke free and ran down the street screaming bloody murder. Seconds later, the sound of three gunshots rattled windows in the ritzy neighborhood.

Cops and EMTs arrived at the scene simultaneously. In the entrance hall, "Boot" Hill, now twelve, stood over his father crying, "They've killed my daddy!" And the boy was dead right.

Even Houstonians, who had come to expect the unexpected from the stranger-than-fiction saga of the Hills and Robinsons, were stunned by the latest bloody chapter. The question asked all around town was whether old man Ash had lost confidence in the courts and resorted to vigilante justice.

The homicide detectives assigned to the case could not have been luckier. Down the block from the murder site, they spotted a handgun in the bushes and traced it back to a colleague of the dead doctor. He admitted to owning what turned out to be the murder weapon but explained that a prostitute by the name of Marcia McKittrick had stolen it from him. He did not report the theft for the usual obvious reasons. One of the investigators remembered

Joan Hill, champion equestrian, with son "Boot" on horseback. *RGD0005f6681, Houston Public Library HMRC.*

McKittrick from his days as a vice cop. A check of the prostitute's old haunts proved productive, as did the identity of her current pimp boyfriend.

Bobby Wayne Vandiver was a hard-core character with connections to the notorious "Dixie Mafia." He was brought in for questioning but kept his mouth shut until John Hill's mother positively identified him as the

intruder who bound and gagged her and her grandson before shooting her son.

Faced with the death penalty, Vandiver confessed to the murder and pointed an accusing finger at two alleged accomplices: McKittrick, who drove the getaway car, and Lilla Paulus, who paid him $5,000 to kill Dr. Hill. Vandiver stated in his confession that Paulus "told me the contract was on a doctor who had killed his wife and that it was the wife's father who was wanting him dead."

While waiting for his day in court, Vandiver and a female companion stayed in a Houston motel courtesy of the district attorney's office. In the summer of 1973, District Attorney Bob Bennett approved an unchaperoned trip to Dallas for Vandiver after the ex-convict promised to be back in September for his trial. To Bennett's chagrin, the hit man was a no-show. Vandiver remained at large until April 1974, when he came out second-best in a quick-draw contest with a policeman in an East Texas café.

In short order, the other two dominoes fell. Marcia McKittrick got ten years for her part in the murder plot and made parole after five. The comparatively short stretch was her reward for helping to put Lilla Paulus away for thirty-five years. The underworld go-between, who went to her grave without naming the person who ordered the hit on John Hill, died in the women's prison at Gatesville in 1986.

As for Ash Robinson, no case was ever made against him in connection with the slaying of his former son-in-law. He left Houston for good in 1979 and spent the rest of his long life in Pensacola, Florida, where he died of natural causes six years later at eighty-seven. Rhea, eighty-six, survived him by two years.

In later years, there was speculation that the real cause of Joan Robinson Hill's suspicious death was toxic shock syndrome, a little-understood ailment in 1969. If true, that would mean John Hill was not a murderer after all but an uncaring husband and a lousy doctor.

Did Politician Meet His Killer at Dairy Queen?

Dairy Queen has been part of small-town life in Texas for generations, although most customers would be surprised to learn that the Lone Star institution is actually an Illinois import. But that disturbing piece of trivia would not harden the soft spot so many Texans have had for DQ, the popular nickname the company eventually adopted, dating back to 1950, when the first location opened in Henderson.

Women are not on the menu, but that did not keep a politician-in-exile from shopping for a new wife at the Dairy Queen in his hometown of Liberty, the third-oldest settlement in the Lone Star State, located halfway between Houston and Beaumont. The last couple of times Price Daniel Jr. had stopped in for a scoop of ice cream or some other frozen treat, he could not help but notice a different treat of the platinum-blond variety waiting tables. Her name was Vickie Moore, a twenty-eight-year-old mother of two, who no longer lived under the same roof with her husband and had her sights set on divorcing him as soon as she could afford it.

Everything went according to Daniel's carefully conceived plan on that fateful afternoon in May 1976. He succeeded in striking up a conversation with the waitress, no great achievement since being friendly and, if the situation required, flirtatious resulted in bigger tips. He waited for the subject of her heart's desire, namely a divorce, to come up, and when it did, he handed her his business card.

Out of simple courtesy, Vickie Moore took a look at the card and flashed the smile that melted the heart of most males attracted to the opposite sex. She even put a cherry on top with, "Oh! You're a lawyer!"

The Daniel family (with Price Sr. at far right and Price Jr. third from right) poses for campaign photo in 1956. *RGD0005f4230, Houston Public Library HMRC.*

Behind her on-the-clock front, Vickie did not know whether to be flattered or insulted. What kind of dimwit would she have to be not to recognize the firstborn son and namesake of Price Daniel, the three-term governor of Texas, United States senator and patriarch of the most prominent family in Liberty? As for Price Jr.'s occupation, was there anyone in the whole county who did not know he had come back to Liberty to practice law?

Truth be known, and many people did know it, the last place Price Daniel Jr. imagined he would be at age thirty-five was the out-of-the-way community of 5,500. Liberty was his father's hometown, not his. Junior was born in Austin in 1941 during the second of Price Sr.'s three terms in the Texas House of Representatives. Other than the four years in the mid-'50s that the Daniels spent in Washington, D.C., while Price Sr. served in the Senate, Junior lived in Austin until he finished high school in 1959 and left home, the Governor's Mansion, to attend college at his father's alma mater in Waco.

Seven years later, with his Baylor undergraduate and law school diplomas in hand, Price Jr. hung out his shingle in Liberty. He went through the

motions of establishing a law practice, but his real job was to get acquainted with his future constituents. In 1968, right on cue, the voters elected the twenty-seven-year-old son to the father's old seat in the state legislature. It was as close as anyone can come in Texas to inheriting a public office.

Price steered clear of controversy, followed his father's sage advice and proved to be a fair-to-middling member of the Democratic majority, which dominated the House. Then all hell broke loose when the Sharpstown stock fraud scandal decimated the leadership ranks in both legislative chambers and even took down Lieutenant Governor Ben Barnes, the "Golden Boy" whom Lyndon Johnson and John Connally had groomed for the Oval Office.

Price Jr. had the good fortune to be thrown clear of the biggest train wreck in twentieth-century Texas politics. His hands were clean, mainly because he had not been in Austin long enough to get them dirty, and he had that impressive pedigree going for him. So, in January 1973, he was selected by unanimous vote as the next Speaker of the House at thirty-one, a year earlier than dear old dad had reached the same rung.

Price Jr. was no reformer—the status quo had treated the Daniels just fine over the years—but he could play the part. He cleaned up much of the god-awful mess left behind by the Sharpstown scandal and pushed through changes that at least offered the angry electorate the hope of a less corrupt legislature.

Price Jr. took a well-deserved bow and, with the cheers still ringing in his ears, went home to Liberty. That had been the catch. In order to step into the limelight as Speaker, he had to promise to exit the stage after a single term.

The next year, Price Jr. made a second serious mistake by risking his popularity to preside over the convention called to rewrite the Texas constitution. It ended up, as anyone could have told him, a long, drawn-out affair that accomplished absolutely nothing. As the man in charge, Price Jr. received the lion's share of the blame and the nickname "Half-Price"—meaning, of course, that he had not lived up to his father's high standards.

That was how Price Daniel Jr. wound up back in Liberty in the summer of 1976. His first wife, a descendant of a turn-of-the-century governor, had thrown in the marital towel well in advance of Price Jr.'s political setback and subsequent exile, and their divorce became final in November 1975.

Daniel was looking for a replacement but had a different sort of woman in mind this time around. Instead of another hard-to-please, pampered wife from an influential family, he desired a more down-to-earth mate who would stand by him come hell or high water.

That was what Daniel believed he saw in Vickie Moore, but he did not see beyond the stereotype of a lower-class girl, the tenth child from an impoverished family of eleven kids, who quit school after the eighth grade and had been on her own ever since. The wife-hunter wanted meek and submissive, and she was strong-willed and not afraid to speak up.

Vickie tried to tell Daniel that he was barking up the wrong tree when he came by the Dairy Queen on a hot June day the month after he clumsily broke the ice. It was his birthday, and he asked her to celebrate the occasion with him at dinner that evening.

He was counting on a gushy acceptance of the invitation but instead got a rhetorical two-by-four upside his head. "Don't you think you're on the wrong side of the tracks?" Vickie shot back without a trace of her trademark smile. She had a slew of suitors—one in particular appeared to be excellent husband material—and the last thing she needed was a stuck-up lawyer/politician in an overpriced suit from a clan that looked down their noses on common folk like her.

Vickie Moore expected her sharp tongue to draw blood and send Price Daniel Jr. running out the door. But even though the loaded question cut him to the quick, it only filled him with a firm resolve to prove her wrong as a giant step toward winning her heart.

Daniel did just that and in record time. By early October, the two had professed their love for each other and had begun to talk about walking down the aisle. What her intended did not know until much later was that Vickie was also considering remarrying her first husband. She was going to tie the knot with somebody but for a week or ten days could not decide who it would be. When she at last eliminated her ex, the politician and the DQ waitress hopped a plane for New Orleans, where Daniel's brother-in-law, a minister, married the mismatched couple on November 1, 1976.

But there was no "happily ever after" for the newlyweds. In Vickie's eyes, Price treated her like "hired help," only with less warmth and compassion than he showed for his all-female office staff. What really drove her up the wall was his miserly nature. Price was the king of the penny-pinchers, doling out the bare minimum for household essentials and allowing his wife a single credit card for gasoline. Vickie was always short of cash and never given a say in financial matters.

Price reneged on his promise to be a loving father to the two young children Vickie brought into the marriage. He did not abuse or mistreat them but merely acted like they did not exist. Vickie excused his behavior with the fact that he was not her kids' biological father, but to her bitter

disappointment, he did not take any more interest in the son she bore him early in the marriage.

In September 1977, Price filed the paperwork to put his name on the Democratic Party primary ballot for Texas attorney general. His father had been elected to the same office at thirty-six, which meant he had to get on the stick to stay on schedule.

Vickie was totally blindsided by the announcement of her husband's candidacy. He had not so much as mentioned the possibility of getting back into politics, much less launching a grueling statewide campaign that would keep him away from home for weeks at a time. Her reaction to the newsflash was to file for divorce, but by year's end, she had told her attorney to forget it. She was not yet ready to call it quits.

As election day drew closer in the spring of 1978, Price Daniel Jr. held a commanding lead in the polls. He had the endorsement of everybody who was anybody in the political establishment, more campaign money than he knew what to do with and, most importantly, his name. But none of that mattered to those Democrats who went to the trouble of voting in the May primary. Daniel was crushed by an opponent whom so-called experts gave no chance of winning. The humiliating defeat made it official: Price Jr. was finished in politics, and he knew it.

If the Daniels' union was a terminally ill patient on life support, the election was an overeager heir who crept into the hospital room and pulled the plug. But neither Price nor Vickie was willing to pronounce the marriage dead. They wasted two and a half more years caught in an endless cycle of conflict and reconciliation. When the birth of a second son in February 1980 failed to bring them closer together, Vickie had had enough.

They continued to share the same residence but slept in separate bedrooms. When they talked, which happened less and less often, it was about the breakup that both now accepted as inevitable. As if to start the New Year off fresh, Vickie filed for the dissolution of the irreparably damaged goods on December 31, 1980, and Price received the legal notice a few days later.

On the stormy night of January 15, 1981, deputy sheriffs answered an emergency call at the home of Price Daniel Jr. They entered the house and found the lord of the manor dead on the floor at the back door. A .22-caliber bullet is so small compared to larger and more lethal calibers of which grown men have been known to absorb a torso-full without losing consciousness, much less dying. But the .22 slug that pierced the politician's abdomen took a sharp turn, split into two pieces and severed his aorta. Price Jr. lost so much blood so fast that he hardly had time to die.

Richard "Racehorse" Haynes helped Vickie Daniel keep her children and stay out of jail. *RGD0005f6588, Houston Public Library HMRC.*

Vickie Daniel was not interrogated by any law enforcement agency or the Liberty County grand jury that returned the murder indictment against her. The fatal shot had come from the .22-caliber rifle she readily admitted holding at the instant it was fired. So what was the point of asking the guilty-as-sin widow any questions?

It is common in the state of Texas for an individual found guilty of a major crime, especially of the violent variety, to lose custody of their minor children. That happens in civil court after, not before, a felony conviction. But if you are Vickie Daniel and your in-laws wield more power than the Almighty, the cart can be put in front of the horse.

Richard "Racehorse" Haynes was riding high after beating a double-murder rap four years earlier for Fort Worth billionaire T. Cullen Davis. The Vickie Daniel case presented the Houston attorney with the golden opportunity to dispel any lingering doubt that he was Percy Foreman's rightful successor as "King of the Courtroom."

Vickie was happy to have Haynes in her corner but not so much with his legally sound advice. The presiding judge in the custody suit brought by Price Jr.'s sister ruled that she could not dispense with the jury without a pretrial deposition and sworn testimony during the trial itself. Haynes stressed that testifying twice was never a good idea and increased the chances of conviction on the murder charge. But Vickie did not want her freedom without her two boys and decided to risk it all in the custody trial.

In the most dramatic part of the six-week trial, Vickie told her version of how her husband met his death, which went like this.

Price came home in his usual foul mood on that cold and rainy night. He put a stack of documents in front of Vickie and ordered her to sign. But with the divorce in the works, she did not blindly obey his orders anymore. She pushed the papers aside, saying she would not sign anything without her attorney's okay. Vickie's answer angered Price, who flew into a violent rage when she inadvertently spilled his mixed drink. He lunged forward, grabbed the defiant woman by the throat and began choking her. At five feet and 110 pounds, she was no physical match for her bigger and stronger husband. He pinned her to floor just as she let out a cry for help.

Vickie's daughter Kimberly, now twelve, came running from her bedroom and jumped on her stepfather's back. Her fearless rescue attempt seemed to bring Price to his senses, and the attack ended as abruptly as it started.

Vickie went into the kitchen to cook dinner for Kimberly and the boys, and Price retreated to another part of the house. After five or ten minutes, she heard him pull down the ceiling stairs and begin rummaging around in

the attic. In a loud voice, he asked her what had happened to his "stuff," the code word for his marijuana stash. Vickie interrupted her kitchen detail and walked down the hall to the bottom of the extended stairs. Then she broke the bad news. His grass was gone. She had flushed it.

Puzzled by Price's silence and presuming that he did not hear her, she started up the attic stairs. That was when he kicked her in the forehead. She landed hard on her back and opened her eyes to see him coming down the stairs with blood in his eyes.

Scrambling to her feet, Vickie fled back down the hall, frantically searching for an escape route or the means to defend herself. She opened a hall closet door to find three loaded weapons. Choosing between a shotgun and a pair of .22 rifles, she reached for one of the bolt-action rifles and, with the reflexes of an experienced hunter, chambered a round.

Vickie turned with weapon in hand to face Price, who was frozen in place at the top of the collapsible stairs. She retraced her steps to the bottom of the stairwell and pleaded with him to leave. He responded with a chilling threat of bodily harm, and she fired a warning shot up the stairwell.

"Then you shot him again, right?" one of Vickie's attorneys asked.

"He came down the stairs real fast and said he was going to kill me, and I backed away. I was scared he was going to hit me again, and I closed my eyes. I heard something funny. I opened my eyes and he was walking away from me." The "funny" noise was the sound of the second shot. Price Daniel Jr. took four, maybe five halting steps before keeling over in an Olympic-sized pool of his own blood.

Haynes and his assistants did a bang-up job, and so did their client. The six-week custody trial concluded with Vickie Daniel retaining her maternal rights. However, everyone knew full well that the initial victory would not amount to a hill of beans if they lost the second round. A murder conviction would probably mean that for years to come, the only time Vickie would see her children was on visiting day at the women's prison in Gatesville.

As the October trial date approached, "Racehorse" Haynes liked the defense's chances. There was no denying that Vickie was a sympathetic figure in Liberty County, and the possibility of prejudicial pressure on the presiding judge had been eliminated by the assignment of a Beaumont jurist to the case. With all that in mind and a prior commitment in Corpus Christi, Haynes delegated the defensive duties to Jack Zimmerman, a partner in his law firm and a leading trial attorney in his own right.

On the opening day of the murder trial, the efficient judge got right down to the business of picking a jury. Zimmerman noticed but did not

immediately recognize a distinguished-looking man in his seventies in the front row furiously scribbling notes. Then it dawned on him that the man was none other than Price Daniel Sr., the retired governor and father of the victim.

Concerned by the chilling effect that the intimidating presence of the elder Daniel could have on jury candidates, Zimmerman asked the judge to remove him. When this request was rejected, he devised a roundabout way to uncover Daniel's real motive. Under oath, Price Sr. confessed that he was keeping a record of negative comments about his family made by prospective jurors. The candid admission left the judge with no choice but to ban the former governor from the courtroom until final arguments.

Like a racehorse forced to carry more weight, the prosecution was handicapped by the sloppiness of the official probe into Price Jr.'s death. The failure of the sheriff's and police departments to interrogate the suspected killer was incomprehensible, as was the identical oversight by the grand jury. Equally mystifying was the fact that the same lawmen did not bother to obtain a warrant before searching the Daniel residence, a glaring mistake that caused the trial judge to throw out the "tainted fruit" of the illegal searches.

From Zimmerman's point of view, the prosecution did not come close to showing that the shooting was anything more than a tragic accident and, therefore, not a crime under Texas law. The defense, on the other hand, presented persuasive scientific evidence from expert witnesses to support its argument that Vickie Daniel did not intentionally pull the trigger a second time.

Certain as he was that an acquittal was in the bag, Jack Zimmerman knew from many high-stakes trials that no one can ever read the minds of a dozen strangers. Instead of risking his client's future on the whims of a jury, he elected to go with what is called "a bench trial." The judge thanked the confused citizens for their public service and sent them on their merry way. He listened with a poker face to the closing arguments from both sides and declared the court in recess for twenty minutes while he pondered his decision.

Twenty minutes later to the second, the judge announced his seven-word verdict: "Mrs. Daniel, I find you not guilty."

The Dairy Queen waitress had her freedom and her children. Who could ask for more than that?

Sources

Bohanan, Sonny. *The Charge: Murder.* Amarillo, TX: Globe-News, 1999.

Chariton, Wallace O., Charlie Eckhardt and Kevin R. Young. *Unsolved Texas Mysteries.* Plano, TX: Wordware Publishing Inc., 1991.

Dorman, Michael. *King of the Courtroom: Percy Foreman for the Defense.* New York: Delacorte Press, 1969.

Handbook of Texas Online. Texas State Historical Association, Austin, Texas.

Malsch, Brownson. *Lone Wolf: Captain M.T. Gonzaullas, the Only Texas Ranger of Spanish Descent.* Austin, TX: Shoal Creek Publishes, 1980.

Neal, Bill. *Sex, Murder and the Unwritten Law: Courting Judicial Mayhem, Texas Style.* Lubbock: Texas Tech University Press, 2009.

———. *Vengeance Is Mine: The Scandalous Love Triangle that Triggered the Boyce-Sneed Feud.* Denton: University of North Texas Press, 2011.

Richmond, Clint. *Fetch the Devil: The Sierra Diablo Murders and Nazi Espionage in America.* Lebanon, NH: University Press of New England, 2014.

Shulman, Terry. "Maurice Barrymore: An English Actor in the Wild West." *Wild West* (April 1998).

Stokes, David R. *The Shooting Salvationist: J. Frank Norris and the Murder that Captivated America.* Hanover, NH: Steerforth Press, 2011.

Thompson, Thomas. *Blood and Money*. New York: Carroll & Graf Publishers, 2001.

Zimmerman, Jack B. "The Trials of Vickie Daniel." *Litigation* (Fall 1982). American Bar Association.

Index

About the Author

B artee Haile began writing "This Week in Texas History" in 1983 for small-town and suburban newspapers across the Lone Star State. Thirty-one years and more than 1,600 columns later, it is the most widely read and longest-running feature of its kind *ever*.

Bartee also was a regular contributor to true-crime magazines back in the 1990s before the disappearance of that genre. He brings a deep understanding of Texas history and a keen insight into the criminal subculture to *Murder Most Texan*.

A fourth- or fifth-generation Texan (he can't really say for sure), Bartee Haile lives in the Houston area with his wife, Gerri.